EIGHTY DRAWINGS

Including

The Weaker Sex
The Story of a Susceptible Bachelor

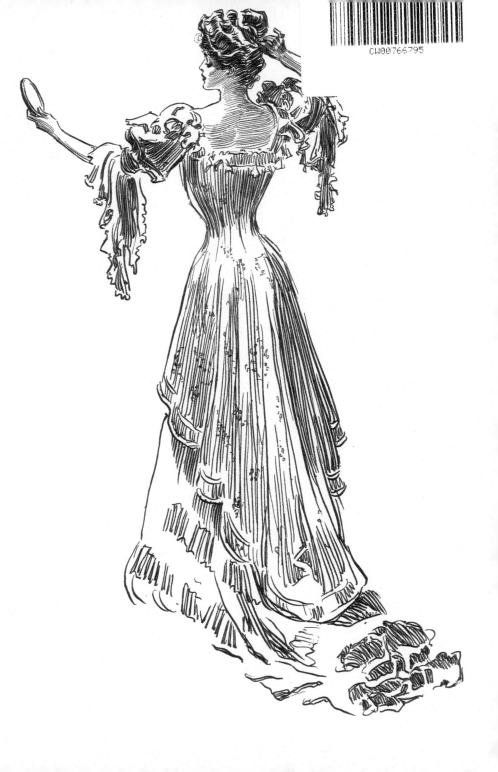

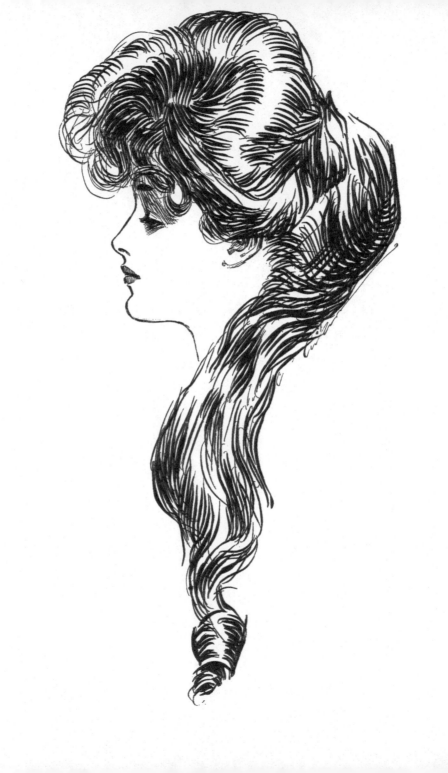

EIGHTY DRAWINGS

Including

The Weaker Sex

The Story of a Susceptible Bachelor

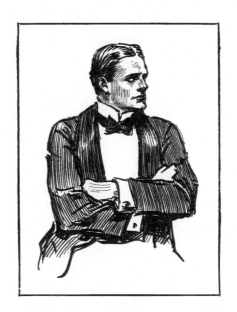

CHARLES DANA GIBSON

DOVER PUBLICATIONS
Garden City, New York

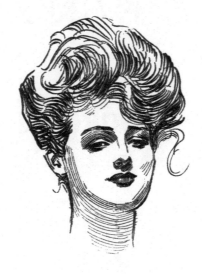

Bibliographical Note

Eighty Drawings, Including "The Weaker Sex: The Story of a Susceptible Bachelor,"
first published by Dover Publications, Inc., in 2013, is a republication of the work
originally published by Charles Scribner's Sons, New York, in 1903.

International Standard Book Number

ISBN-13: 978-0-486-49104-2
ISBN-10: 0-486-49104-8

Manufactured in the United States of America
49104802 2021
www.doverpublications.com

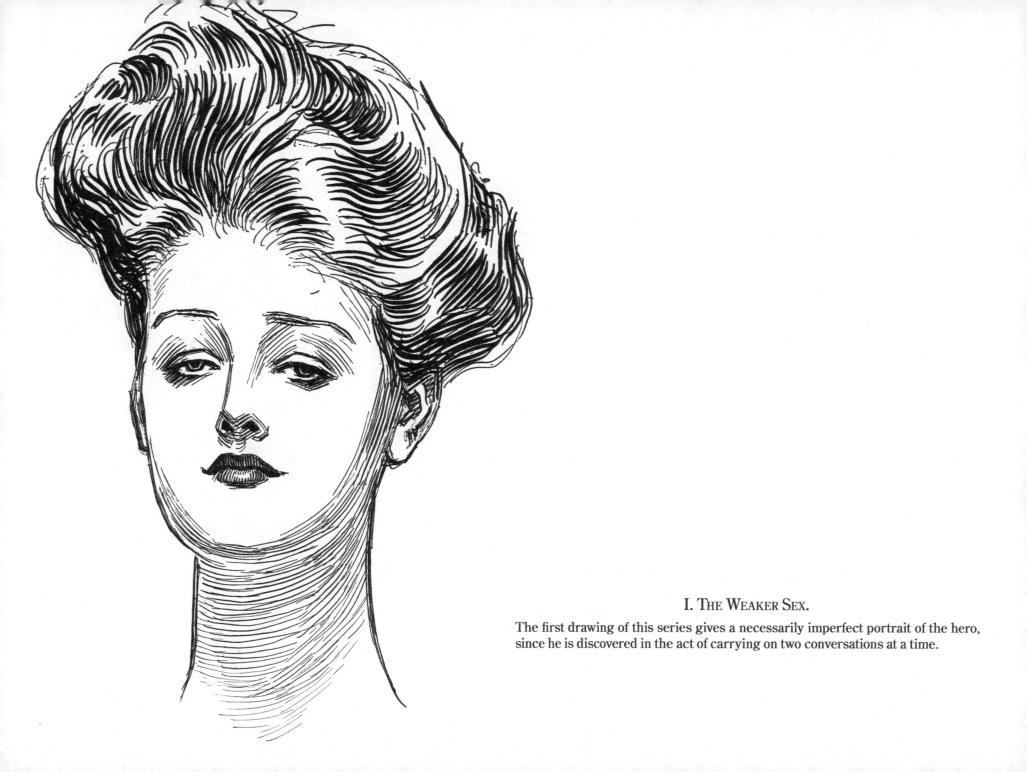

I. THE WEAKER SEX.

The first drawing of this series gives a necessarily imperfect portrait of the hero, since he is discovered in the act of carrying on two conversations at a time.

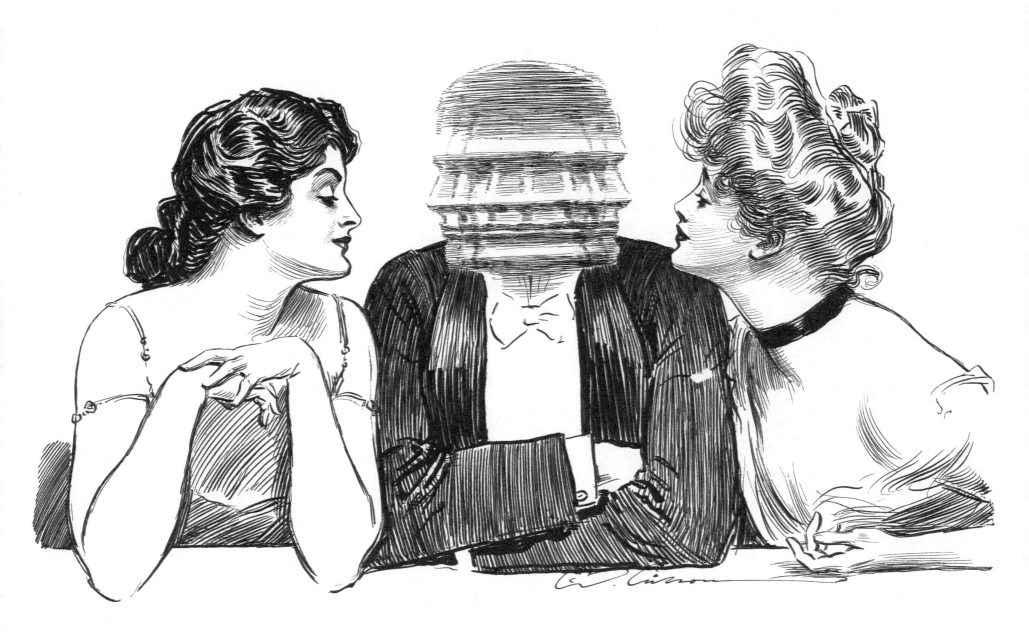

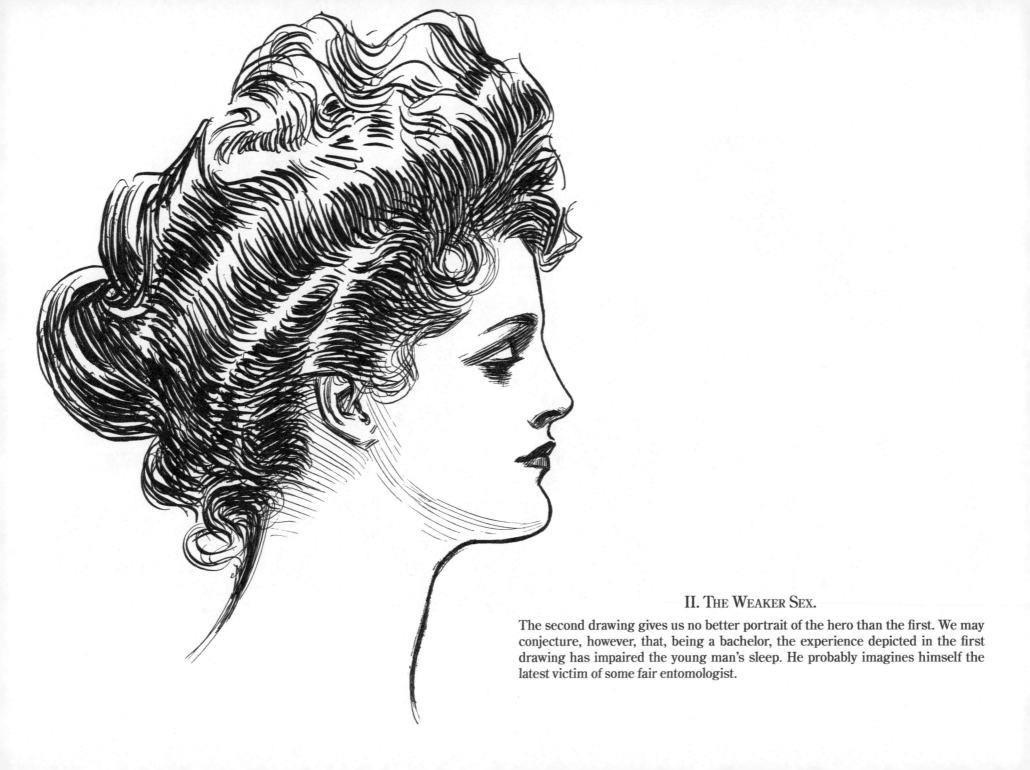

II. THE WEAKER SEX.

The second drawing gives us no better portrait of the hero than the first. We may conjecture, however, that, being a bachelor, the experience depicted in the first drawing has impaired the young man's sleep. He probably imagines himself the latest victim of some fair entomologist.

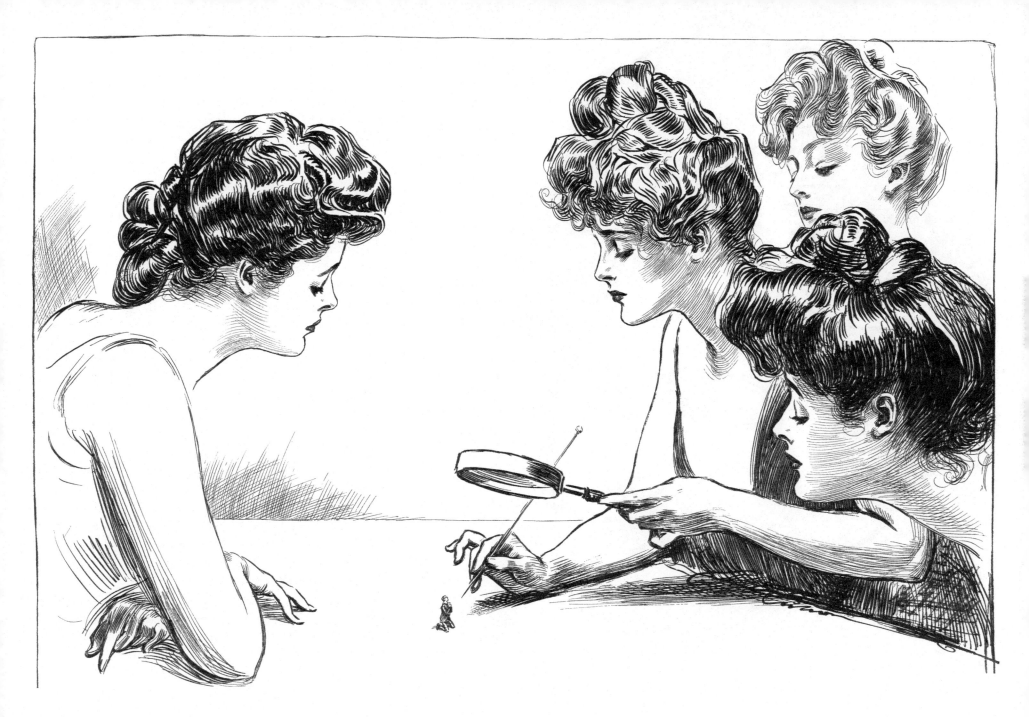

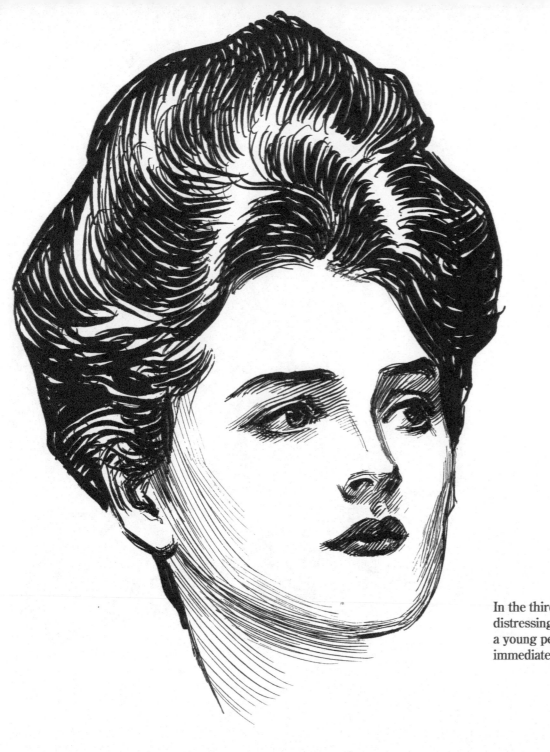

III. THE WEAKER SEX.

In the third drawing of this series we get a portrait of the hero. But he is again in a distressing dilemma. Just as he is advised by his physician to avoid all excitement, a young person enters and he develops further alarming symptoms, whereupon an immediate change of scene is prescribed.

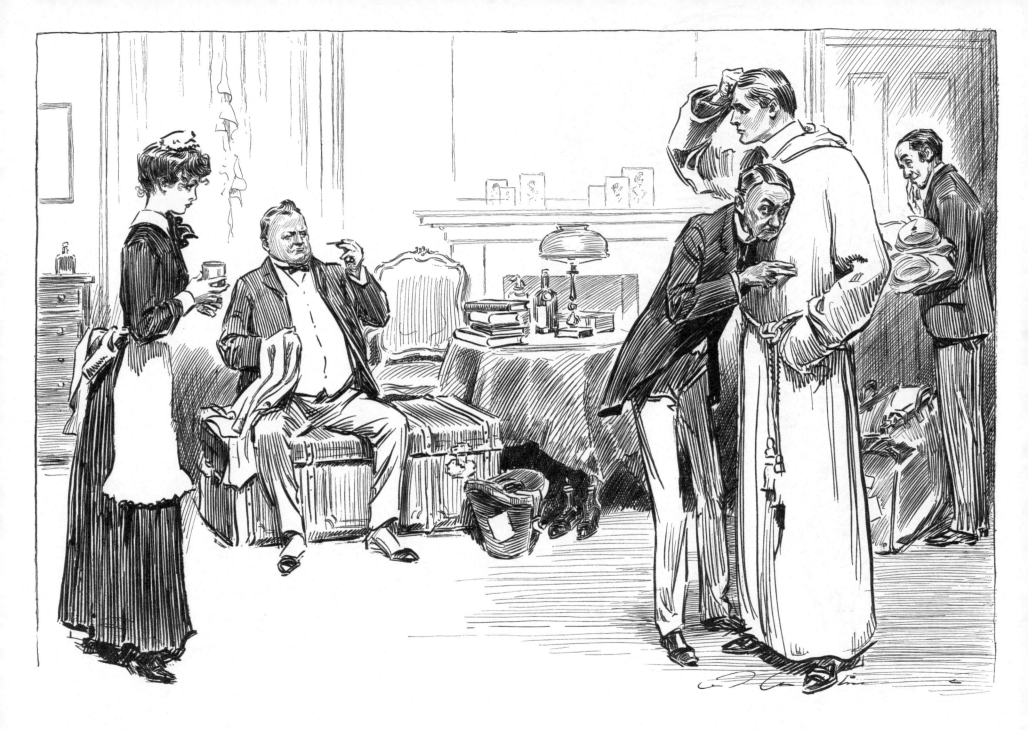

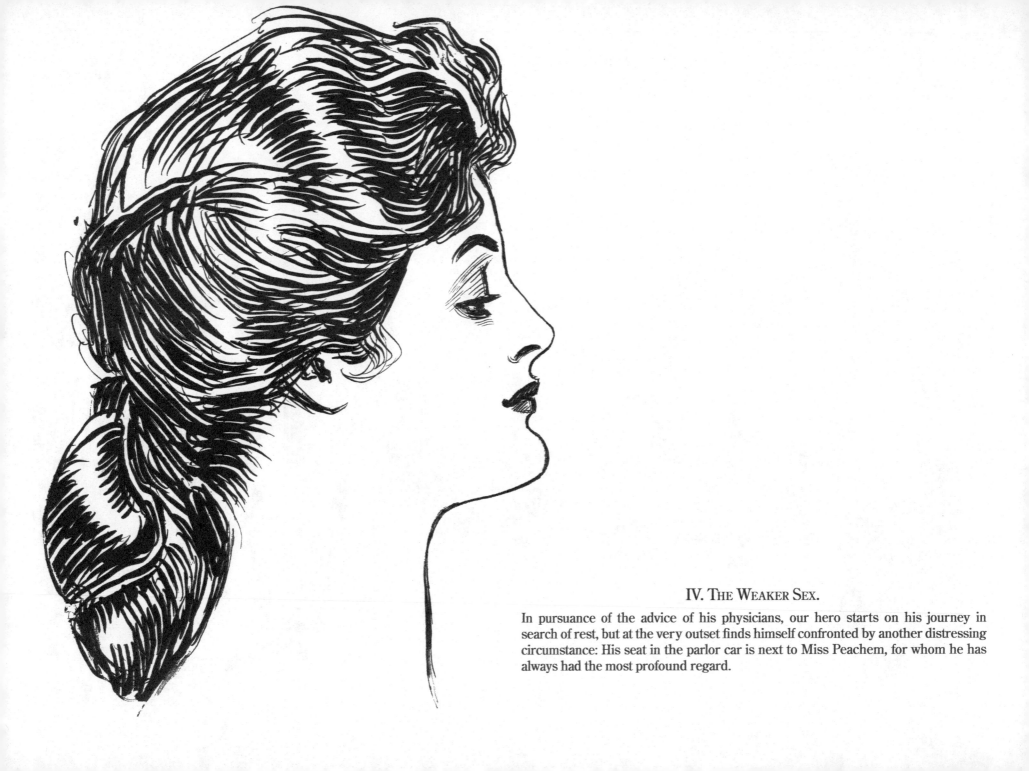

IV. THE WEAKER SEX.

In pursuance of the advice of his physicians, our hero starts on his journey in search of rest, but at the very outset finds himself confronted by another distressing circumstance: His seat in the parlor car is next to Miss Peachem, for whom he has always had the most profound regard.

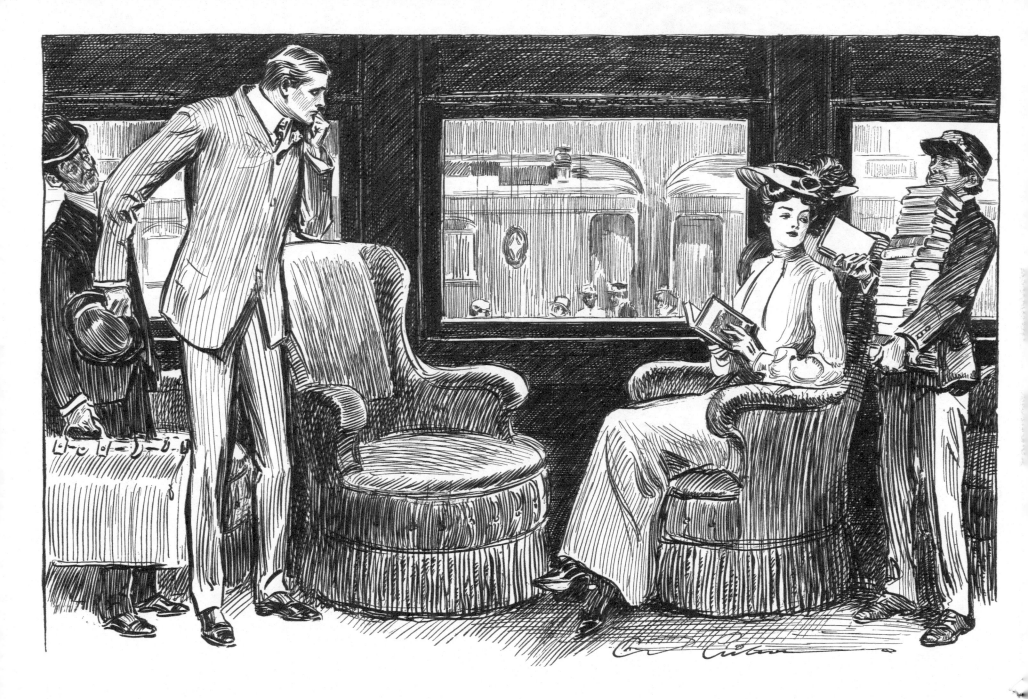

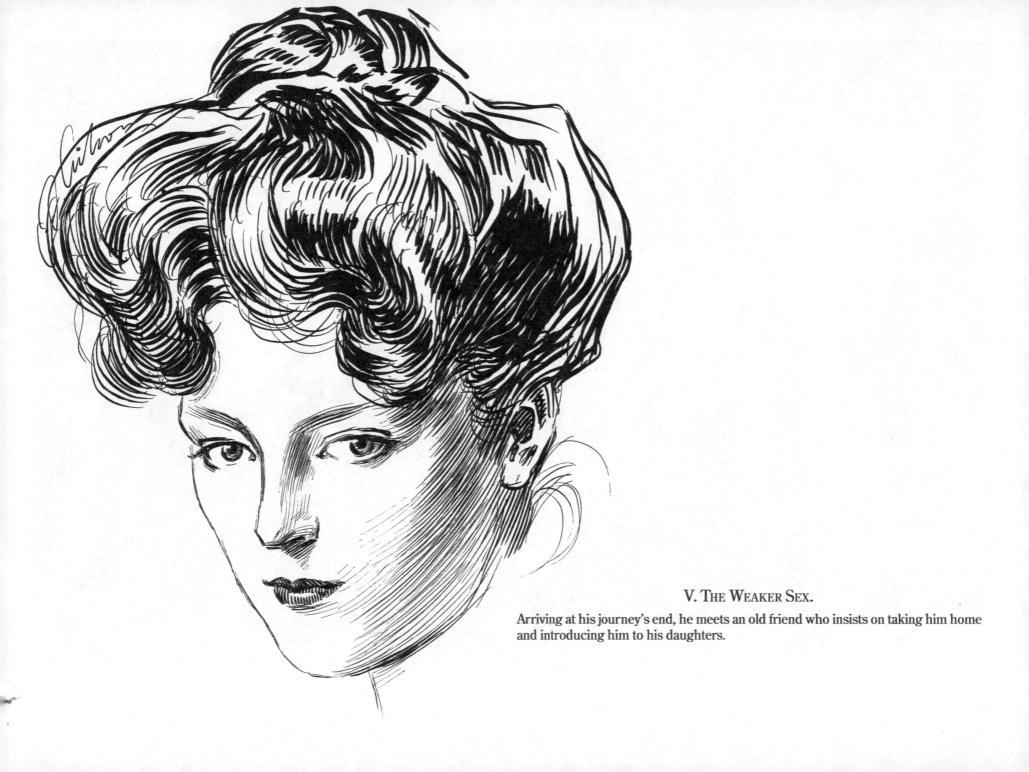

V. THE WEAKER SEX.

Arriving at his journey's end, he meets an old friend who insists on taking him home and introducing him to his daughters.

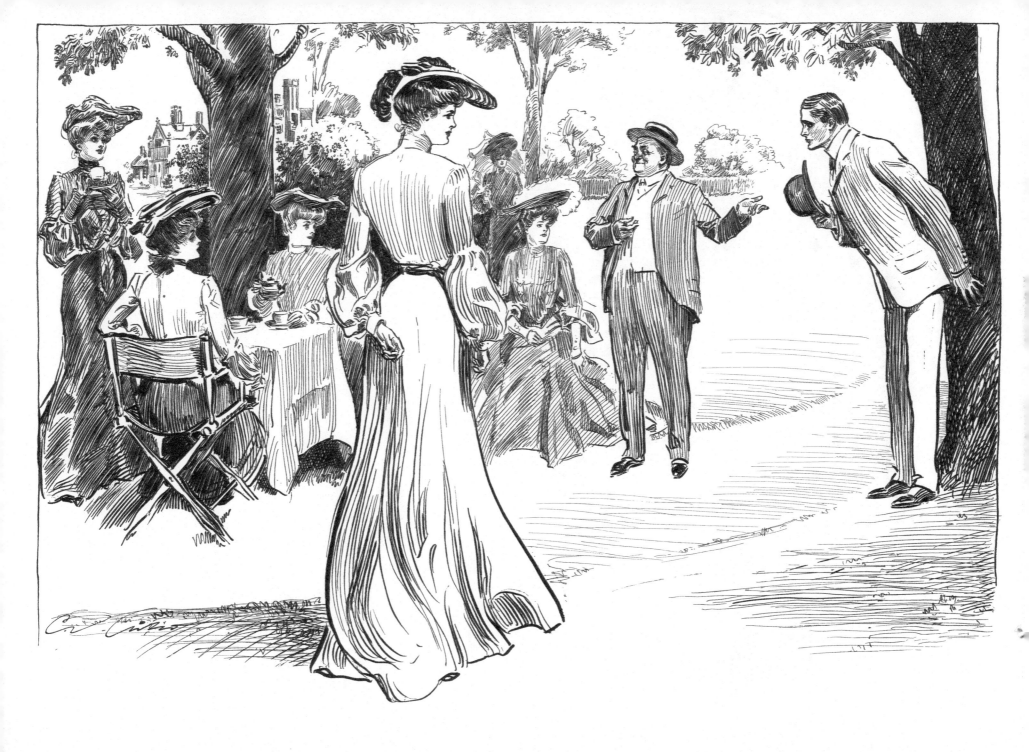

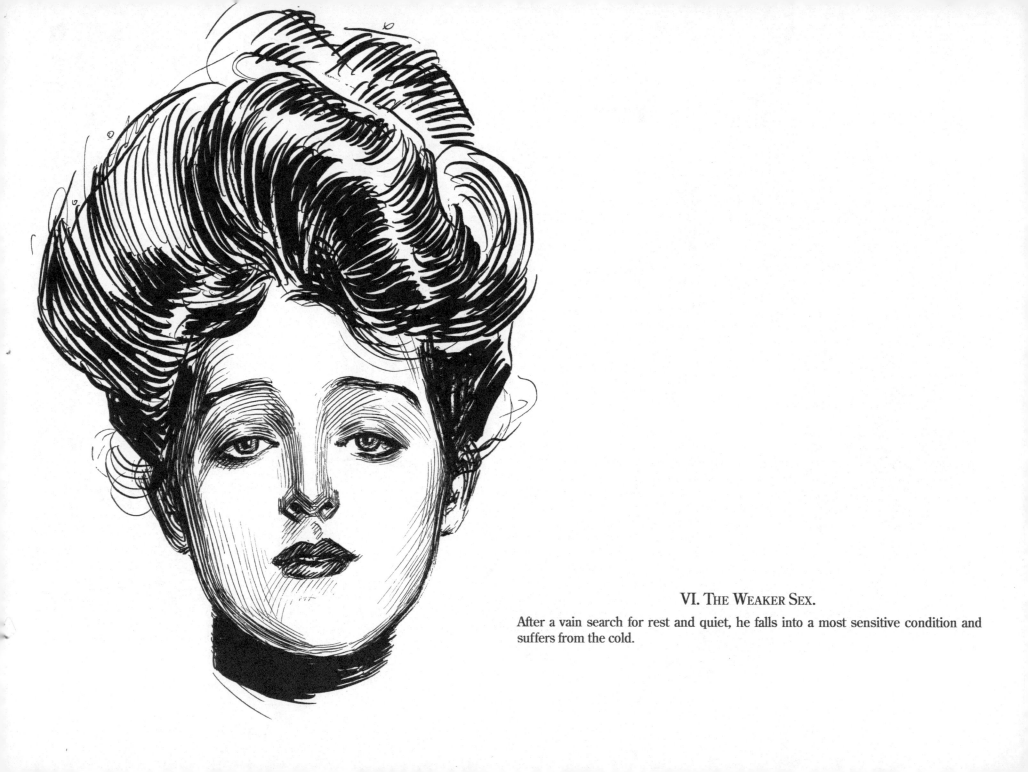

VI. THE WEAKER SEX.

After a vain search for rest and quiet, he falls into a most sensitive condition and suffers from the cold.

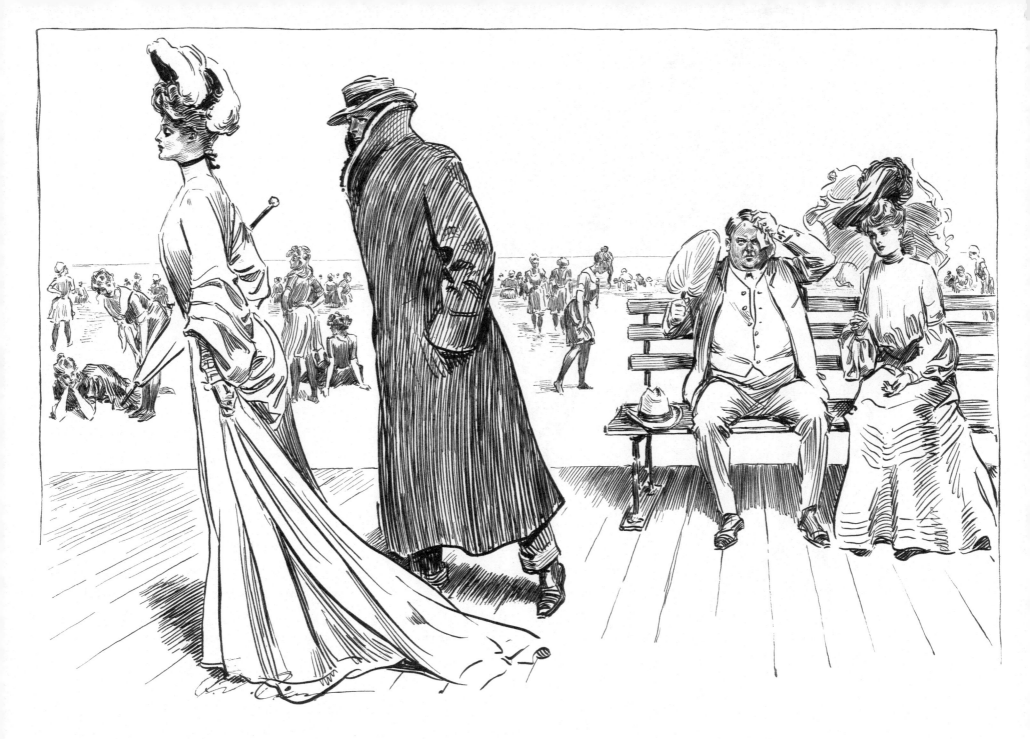

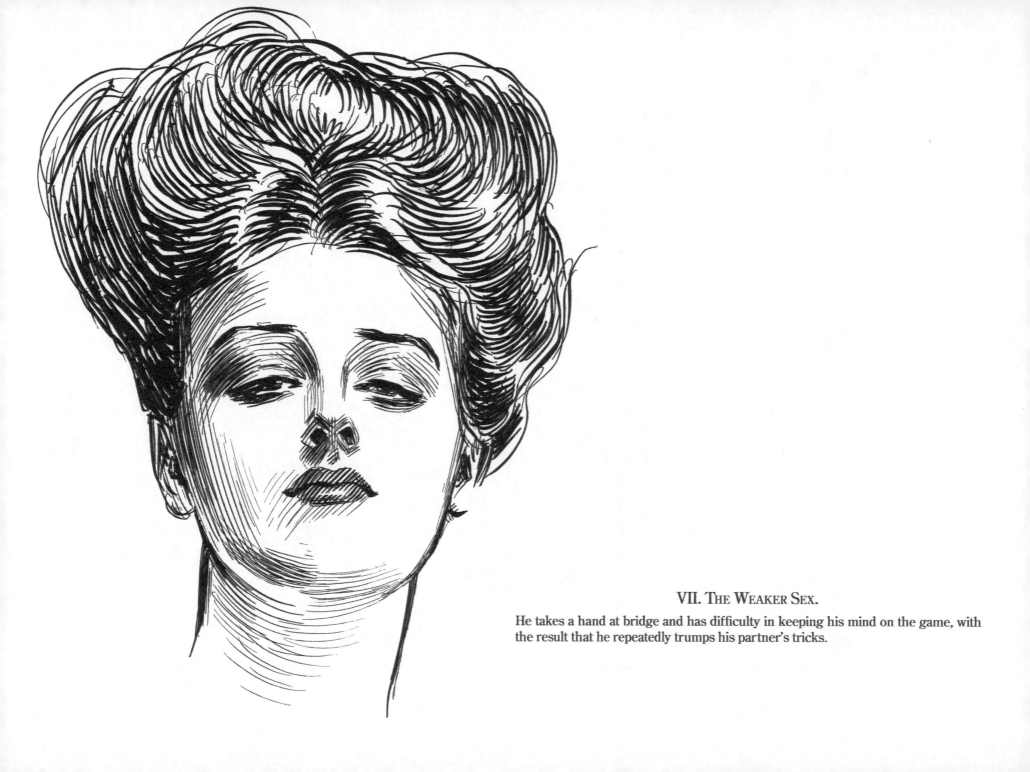

VII. The Weaker Sex.

He takes a hand at bridge and has difficulty in keeping his mind on the game, with the result that he repeatedly trumps his partner's tricks.

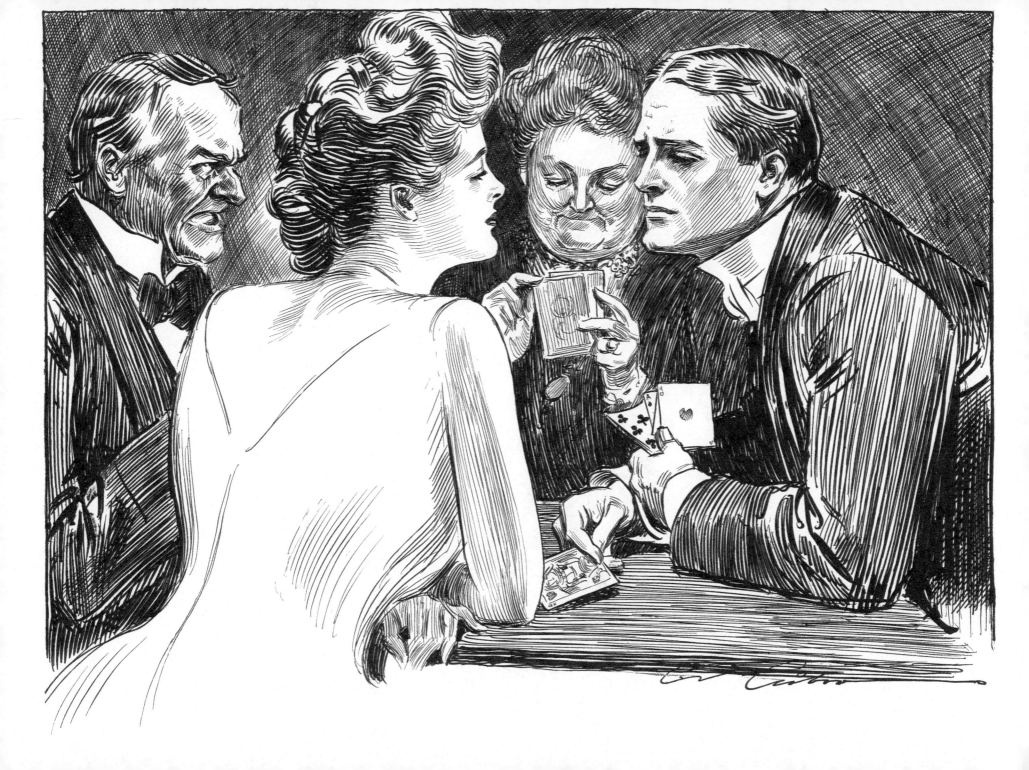

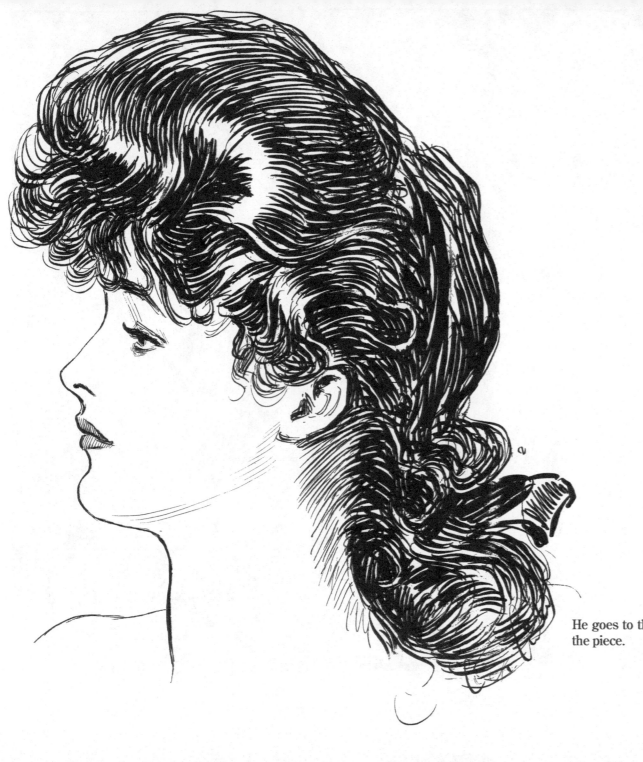

VIII. The Weaker Sex.

He goes to the play, but finds it impossible to become interested in the piece.

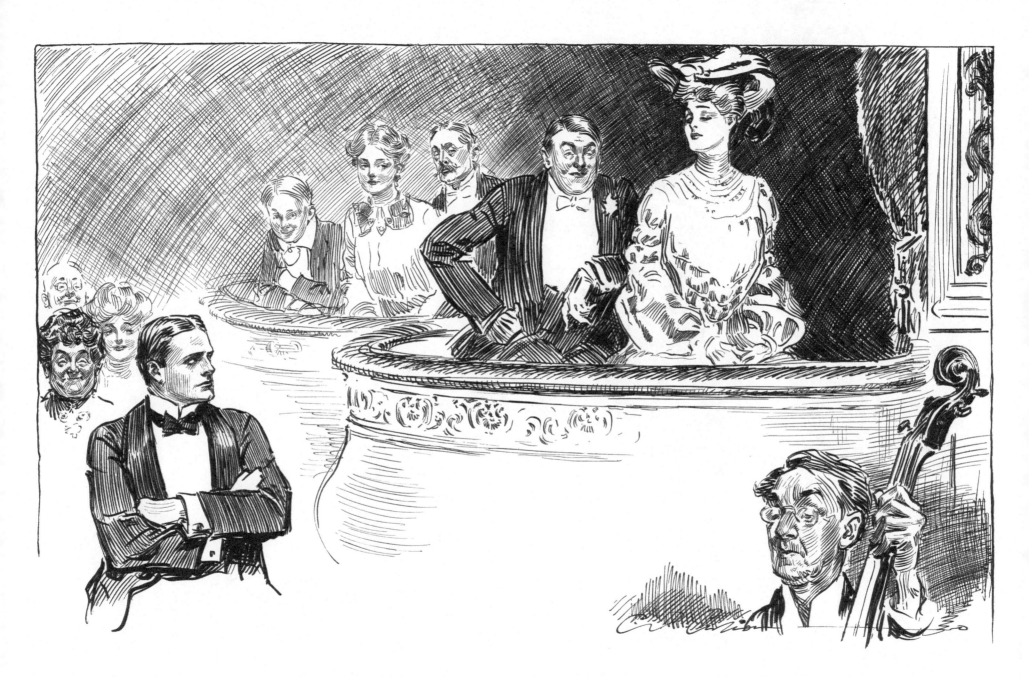

IX. THE WEAKER SEX.

He suddenly loses all interest in foot-ball.

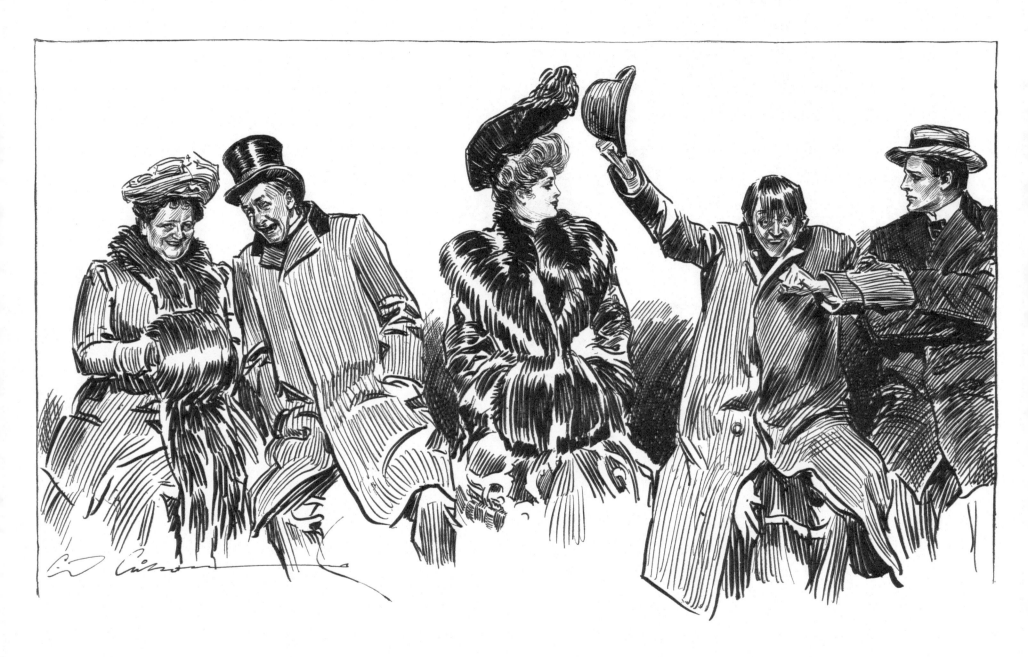

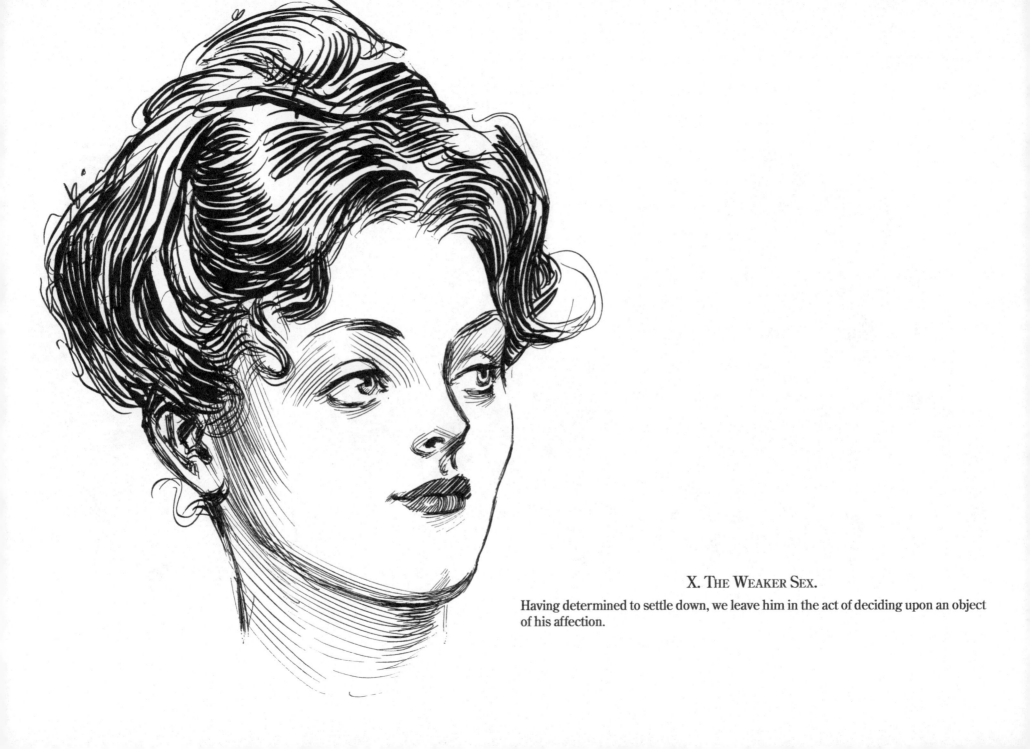

X. THE WEAKER SEX.

Having determined to settle down, we leave him in the act of deciding upon an object of his affection.

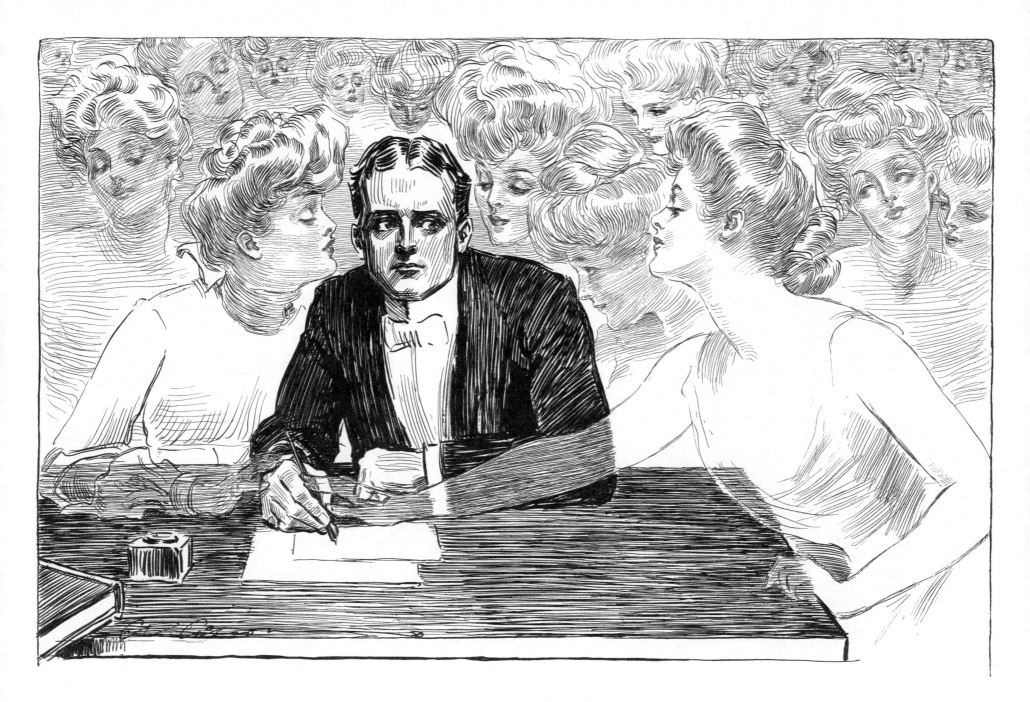

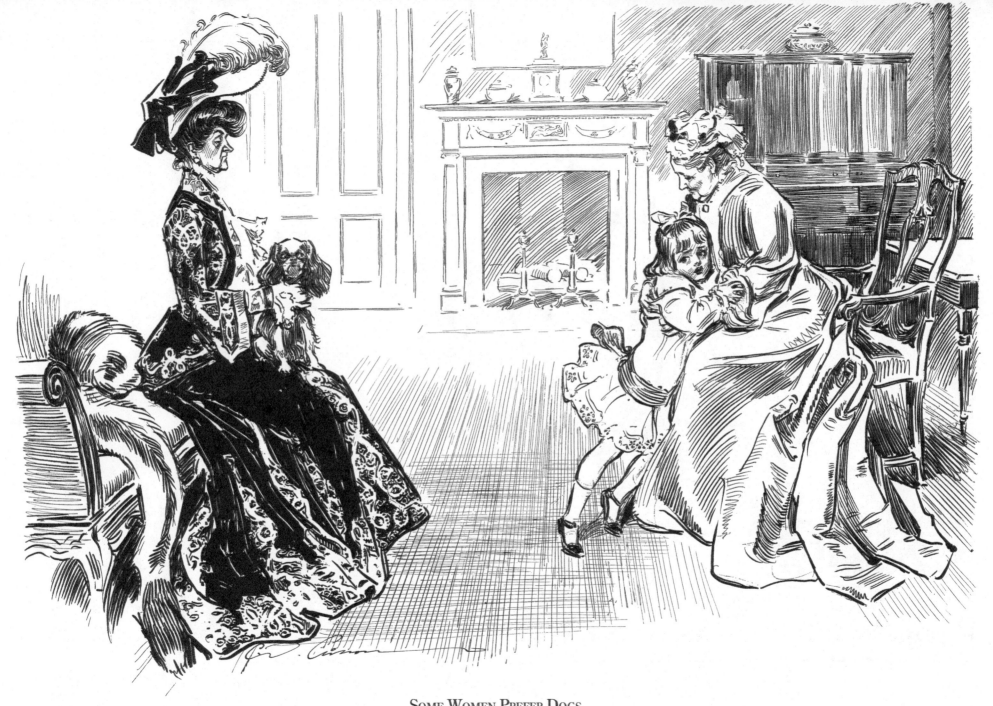

SOME WOMEN PREFER DOGS.

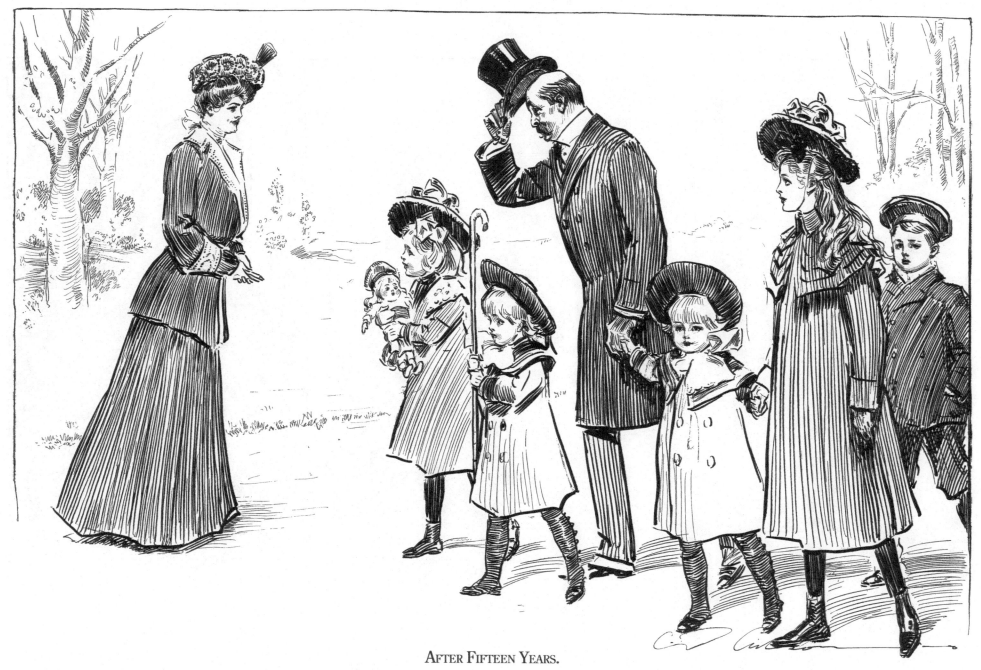

AFTER FIFTEEN YEARS.

When she refused him he vowed he would never marry.

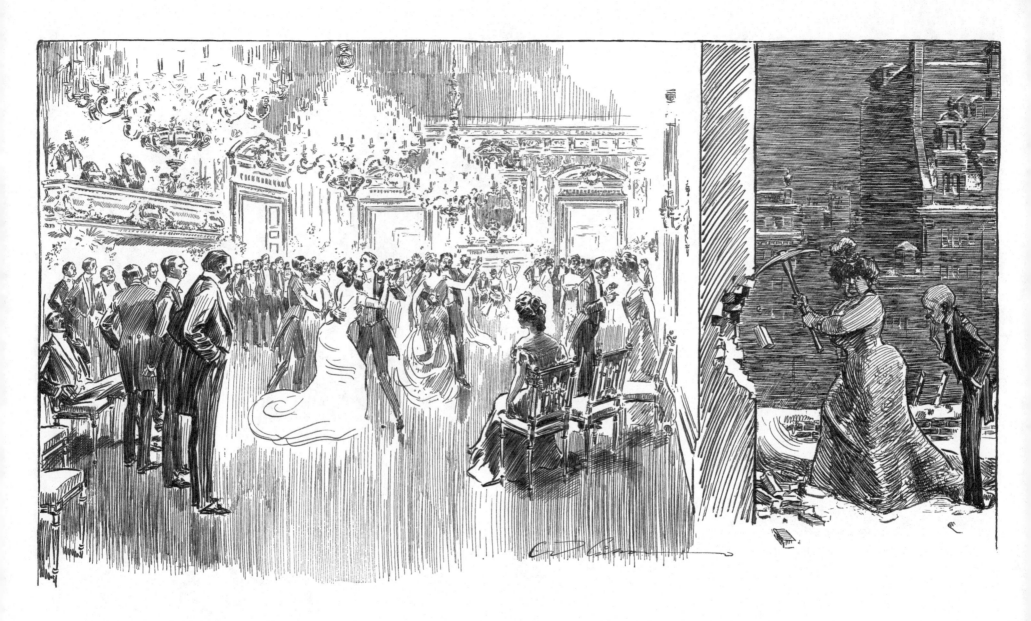

THE SOCIAL PUSH.

Almost in.

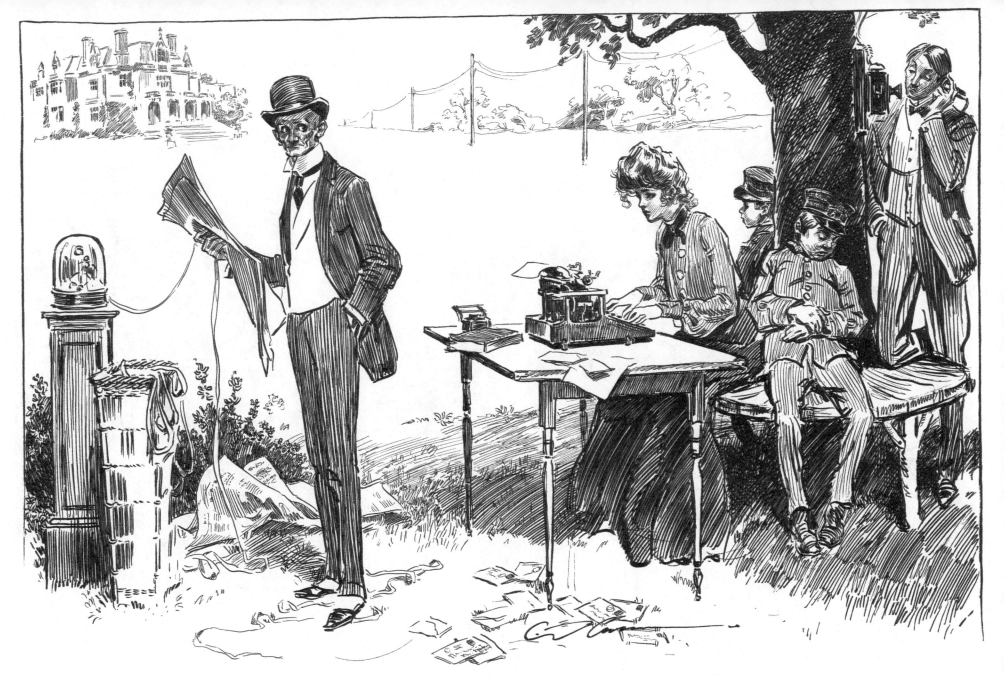

MR. A. MERGER HOGG IS TAKING A FEW DAYS'
MUCH-NEEDED REST AT HIS COUNTRY HOME.

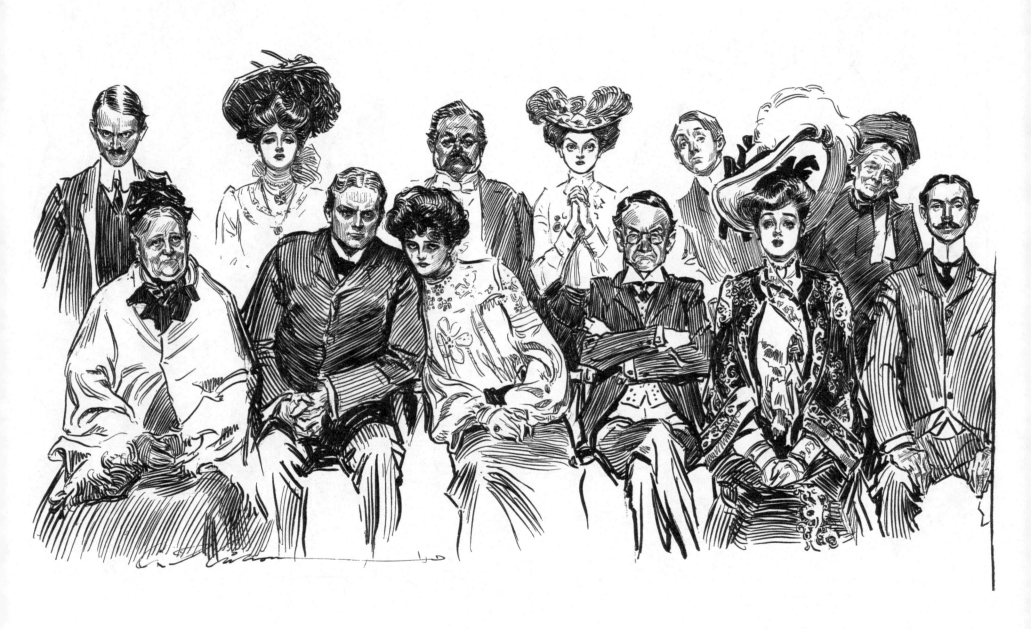

THE JURY OF THE FUTURE—ONE THAT MIGHT TEMPER JUSTICE WITH MERCY.

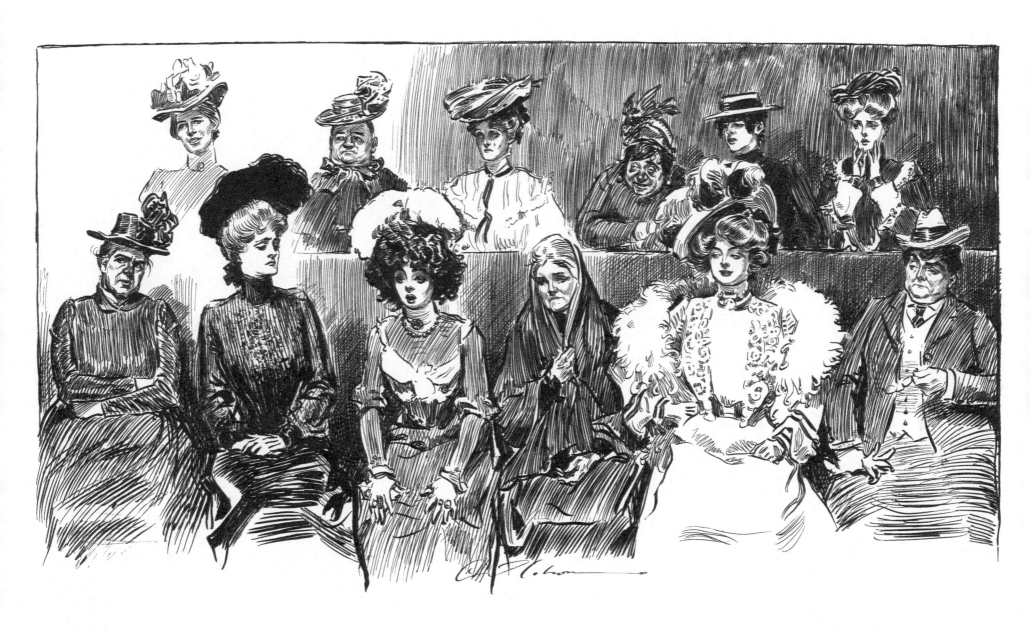

STUDIES IN EXPRESSION.

When women are jurors.

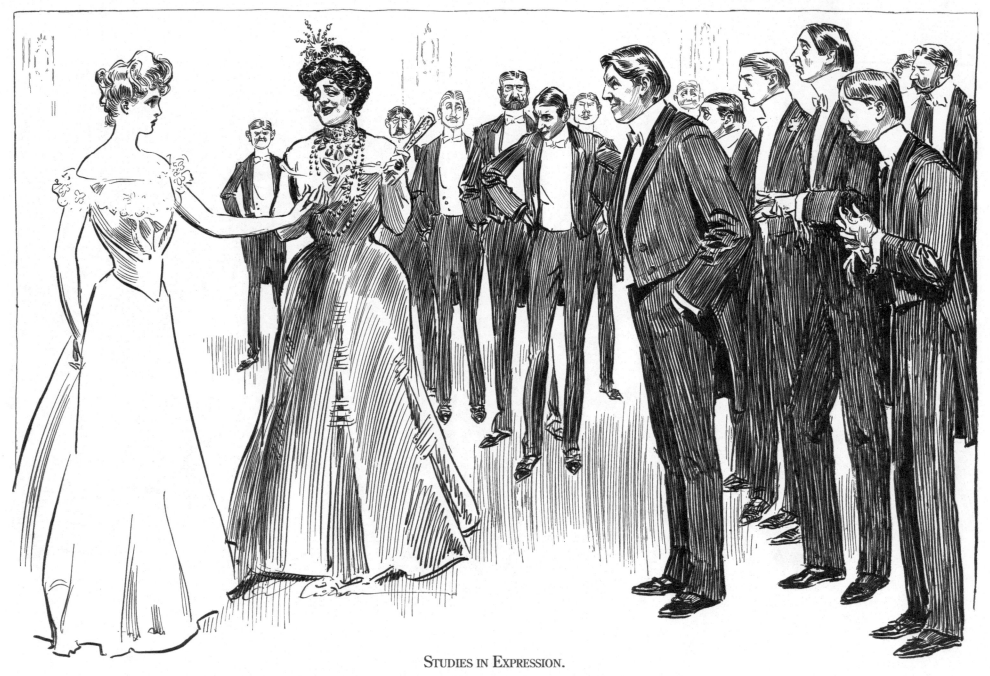

STUDIES IN EXPRESSION.

When a debutante meets the eligible young men of her mother's acquaintance.

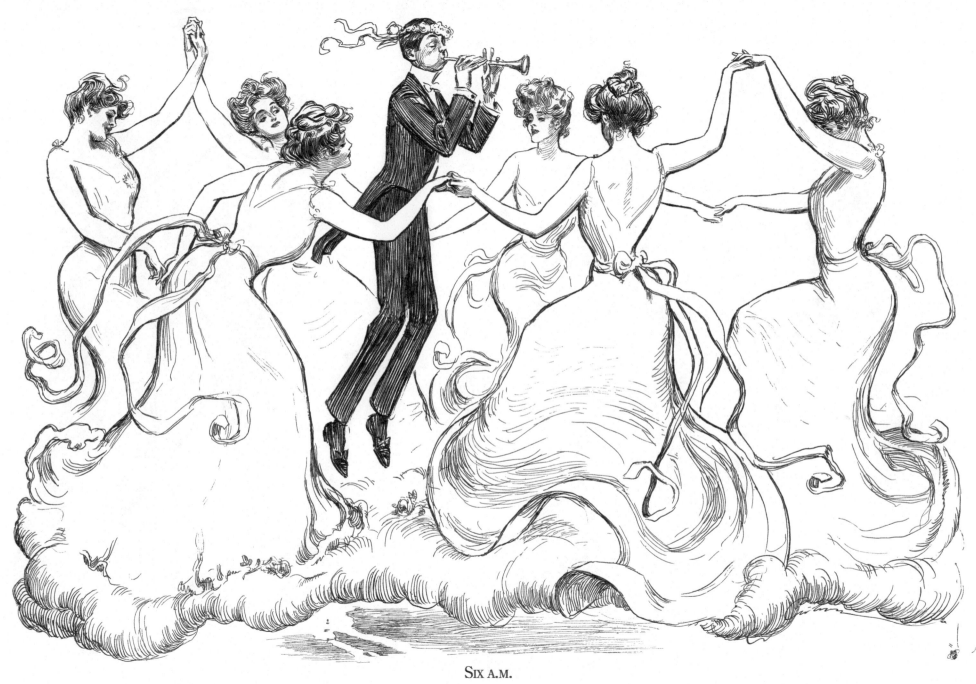

SIX A.M.

Just before he awoke.

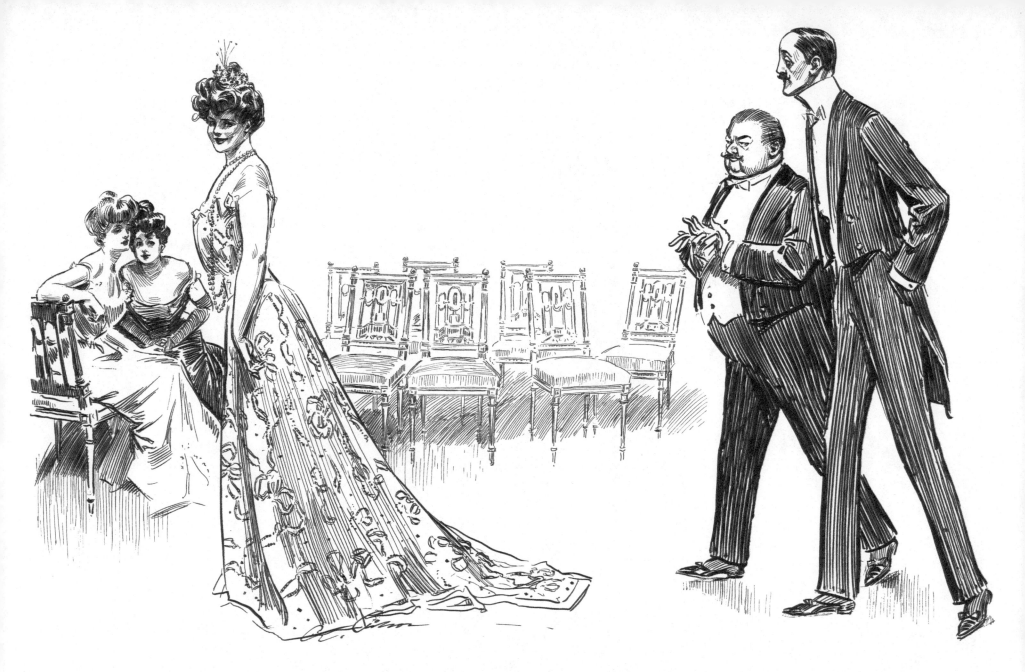

"Both those lords are after her, and she doesn't know which to accept."
"Isn't one as good as the other?"
"Yes, but she can't tell in advance which one is the cheaper."

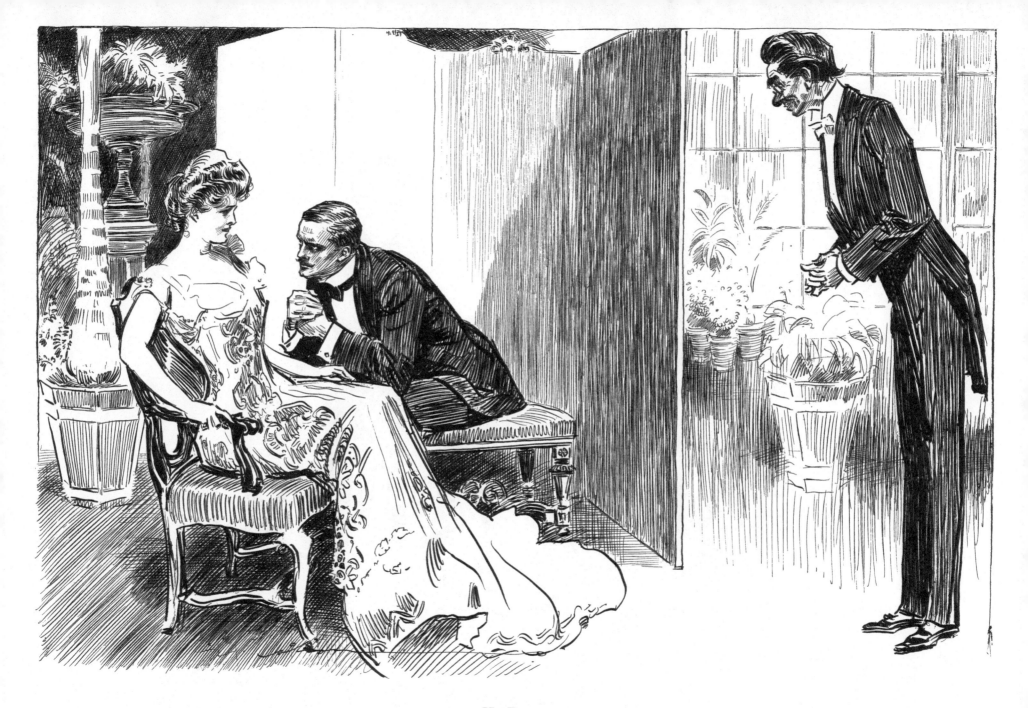

His Dance.

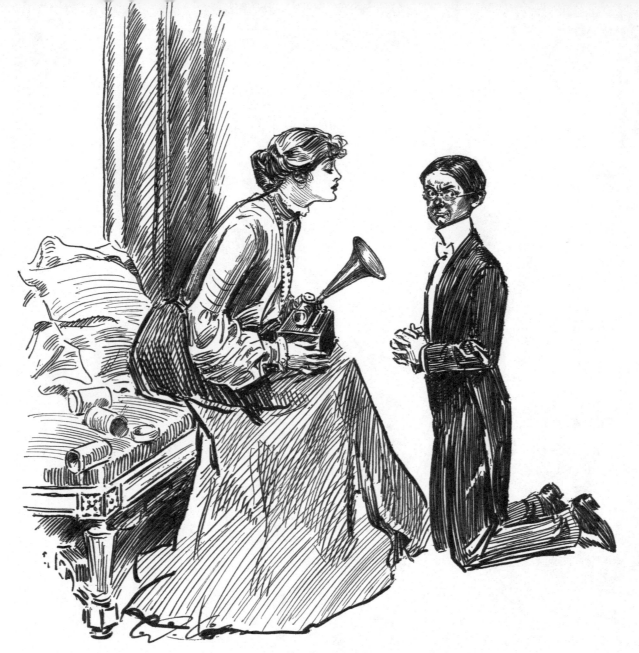

A LAST REMEMBRANCE.

Ethel (ecstatically): "Oh, Charlie, would you just as leave propose all over again, and do it into this phonograph?"

Cholly: "Why?"

Ethel: "Why, I want to have something to remember you by after you have gone in and spoken to Papa about it."

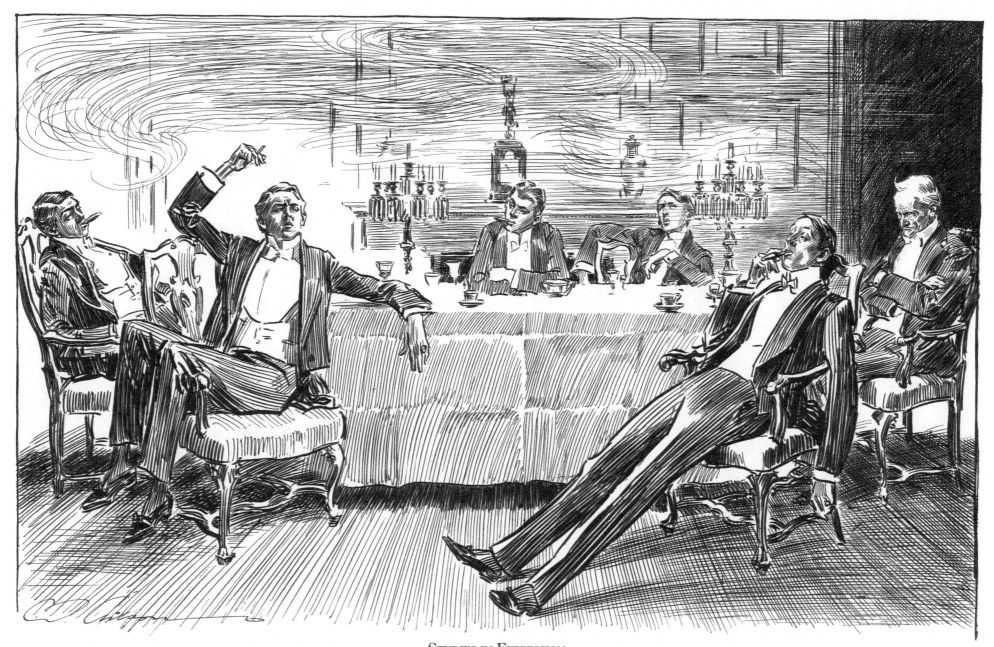

STUDIES IN EXPRESSION.

While an old gentleman listens to some of his son's classmates.

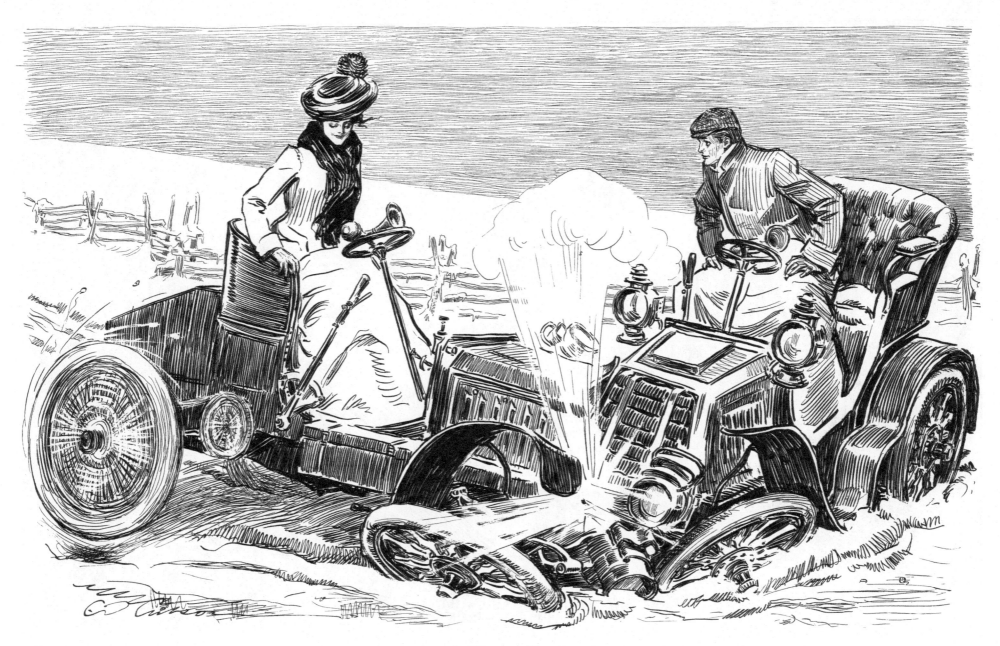

ALL BROKEN UP.

Another collision with serious results.

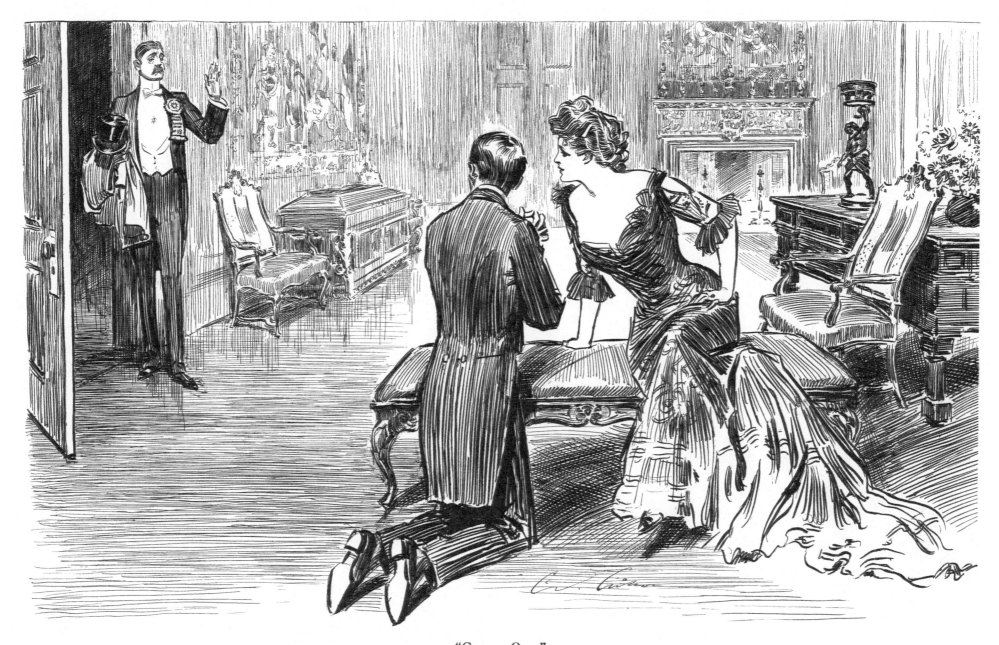

"Called Out."

A possibility of the future when society shall have become thoroughly unionized.

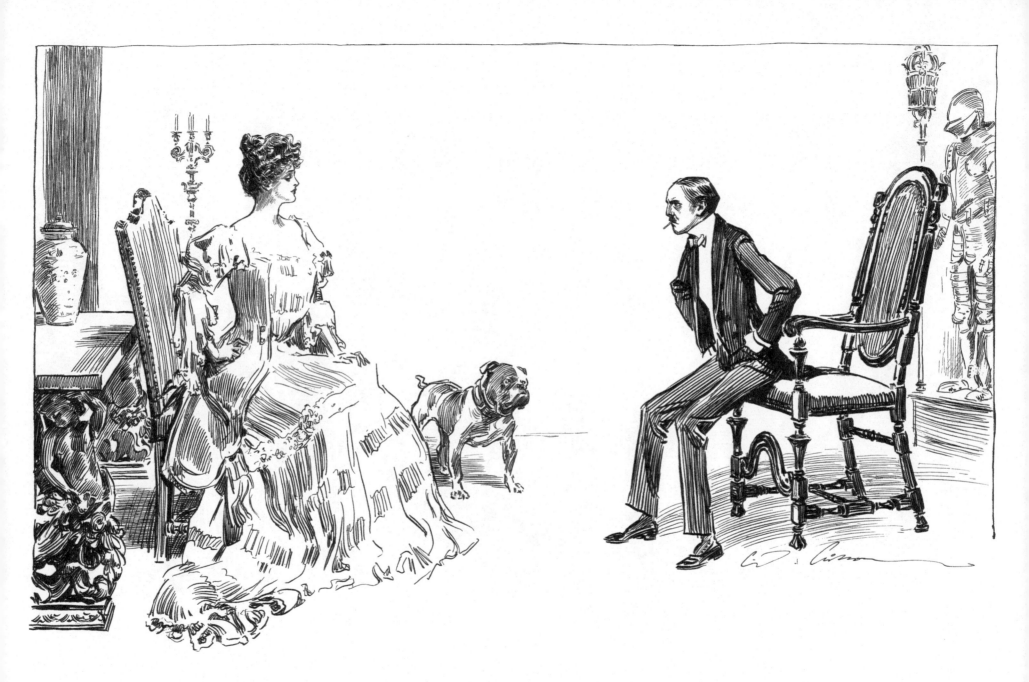

He: "And so you won't let me be yours."

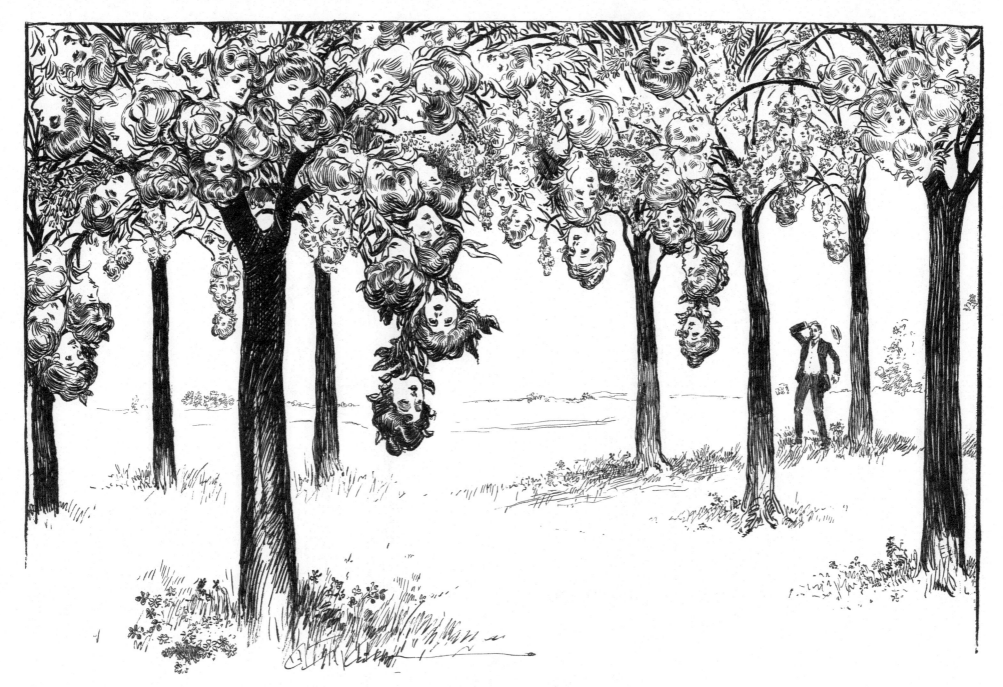

A Peach Crop.

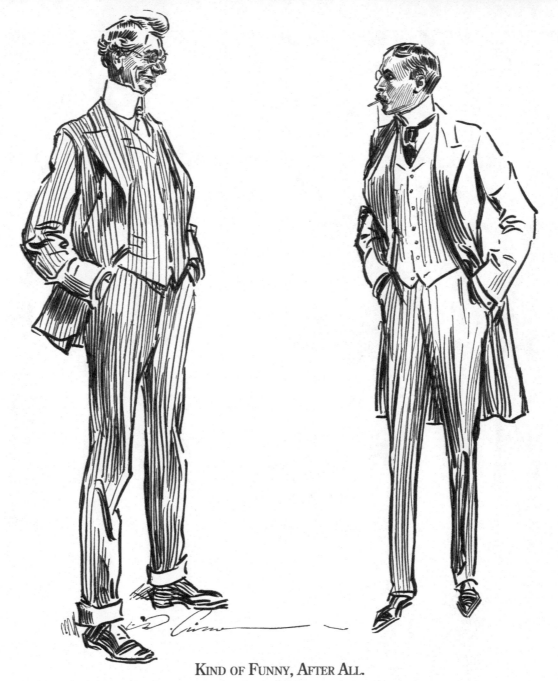

KIND OF FUNNY, AFTER ALL.

"It's no laughing matter to be rejected by a million dollars!"
"Well, I don't know. You see, old man, she's just accepted me."

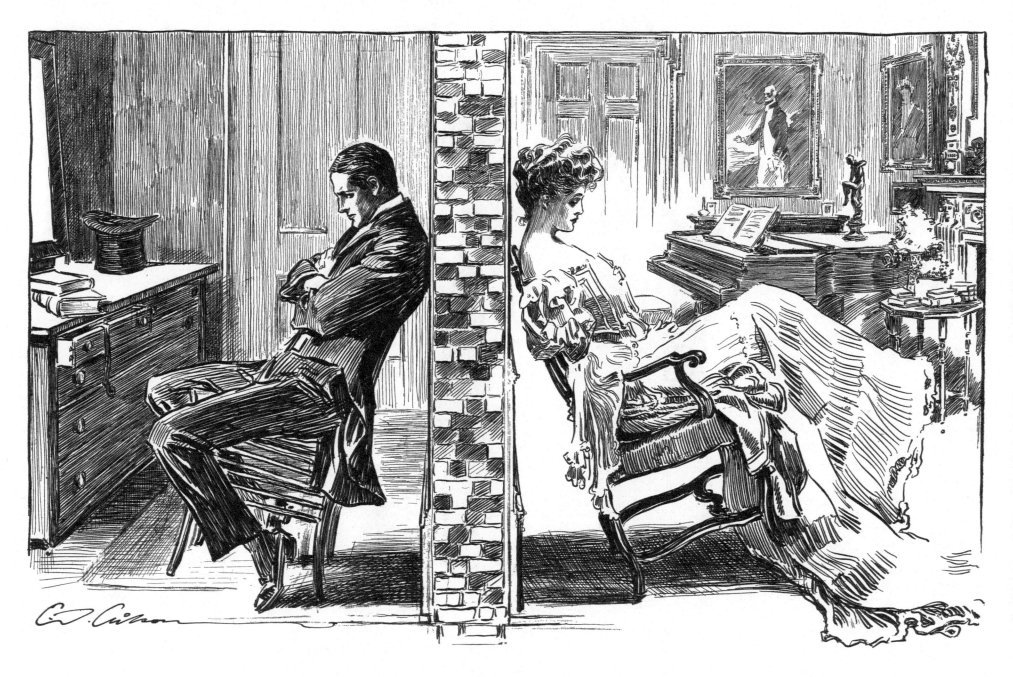

THE PARTY WALL.

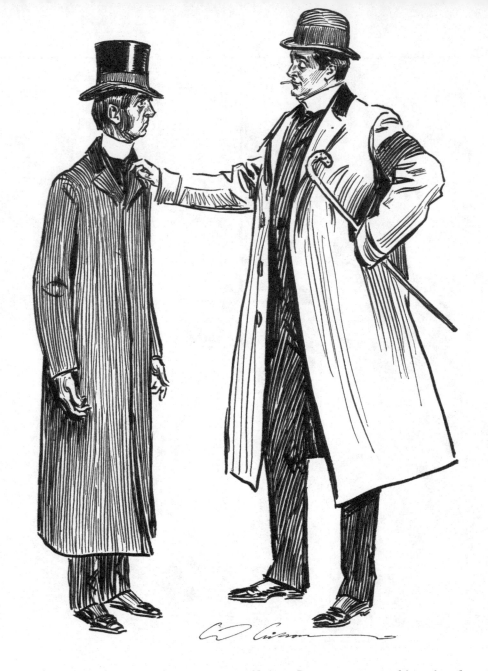

"My uncle died yesterday, sir, and I want you to officiate. Can you say something nice about him?"
"But I didn't know him."
"Good! You're just the man."

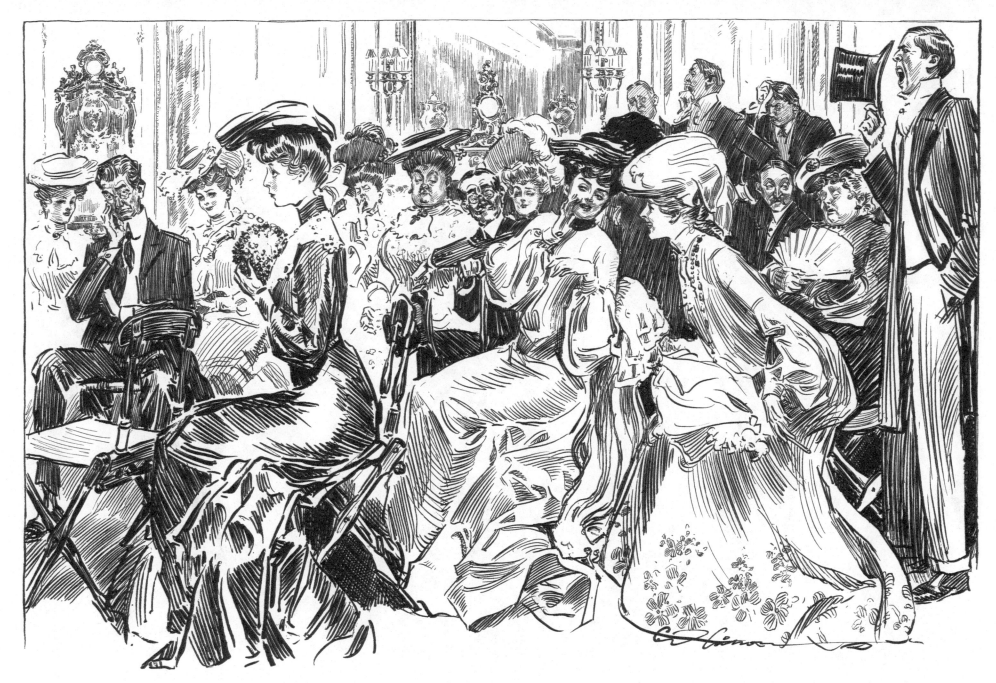

AT A FASHIONABLE FUNERAL.

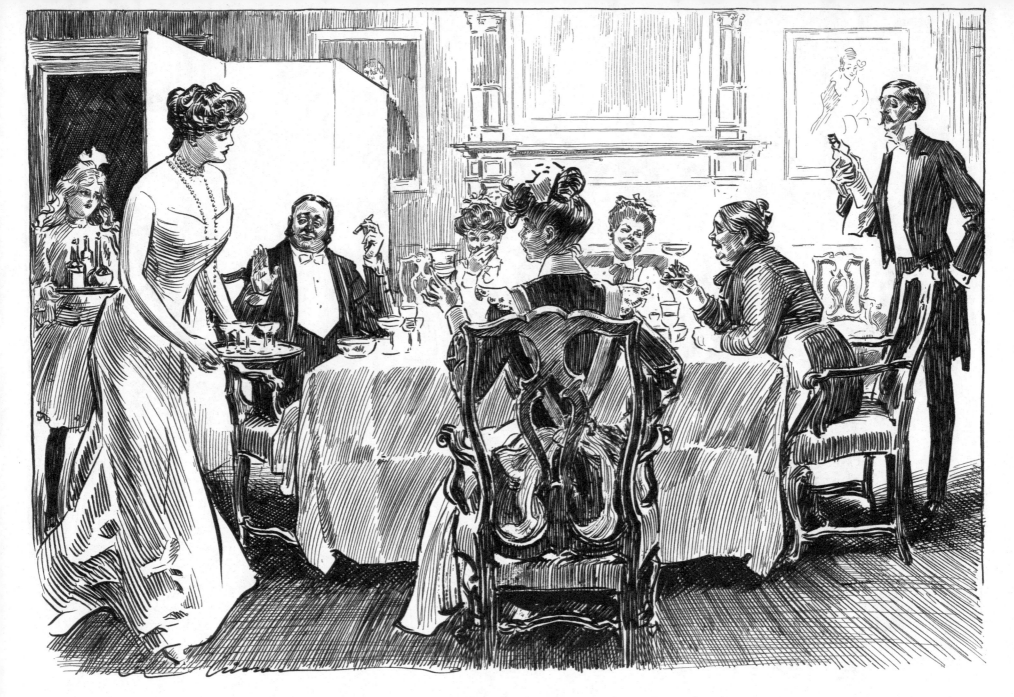

BY WAY OF A CHANGE.

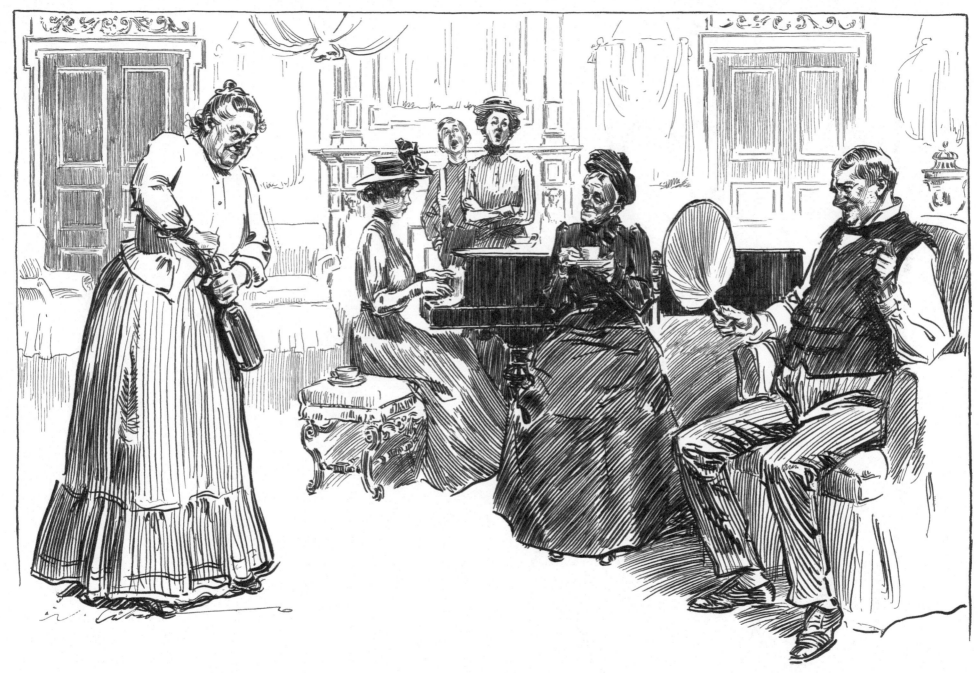

Some of the Caretaker's Relations.

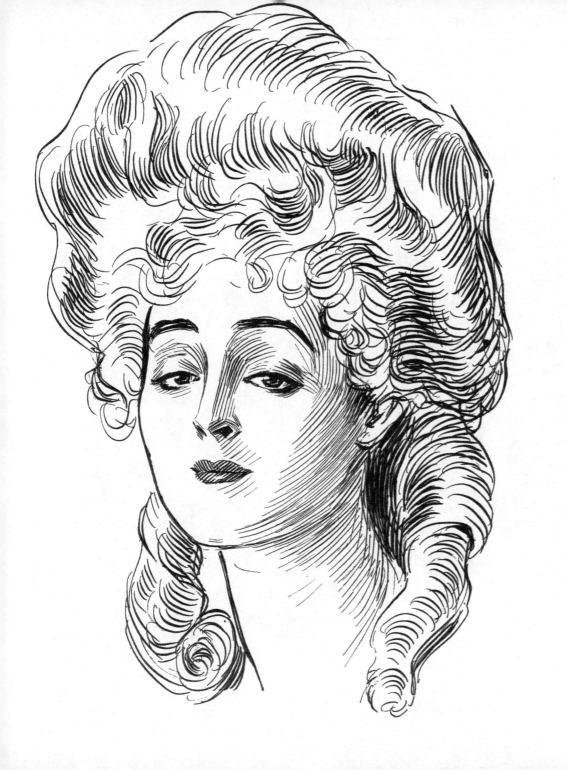

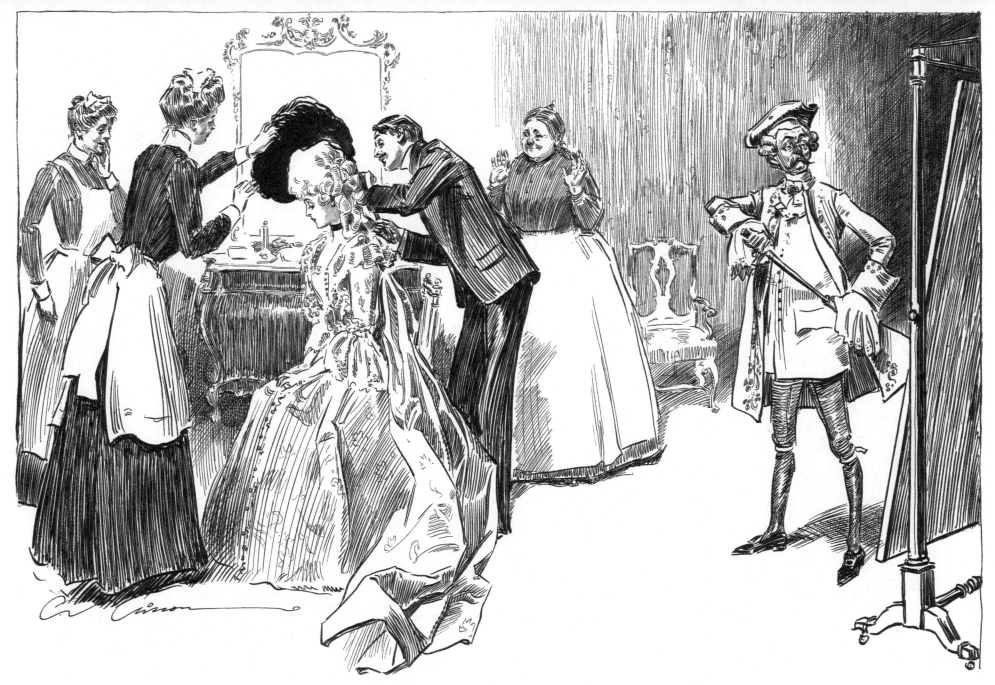

PORTRAIT OF THE GENTLEMAN WHO WAS UNWILLING TO ATTEND A FANCY DRESS BALL
UNTIL HE SAW HIMSELF IN A COSTUME.

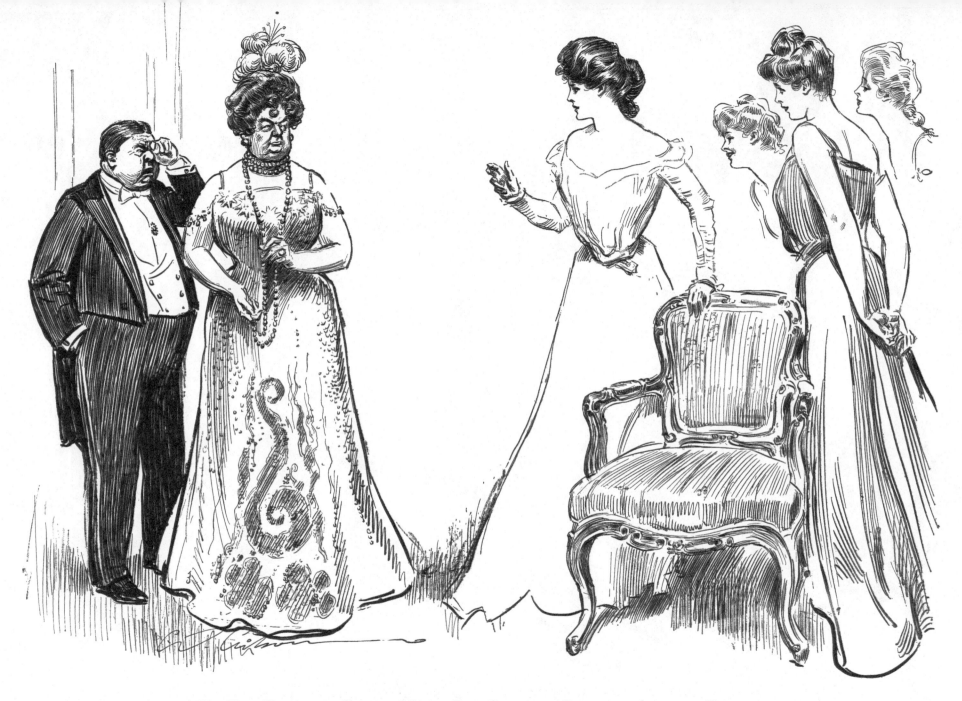

THE FIRST DUTY OF AN OPULENT MOTHER IS TO SHIELD HER CHILD FROM AMBITIOUS FEMALES.

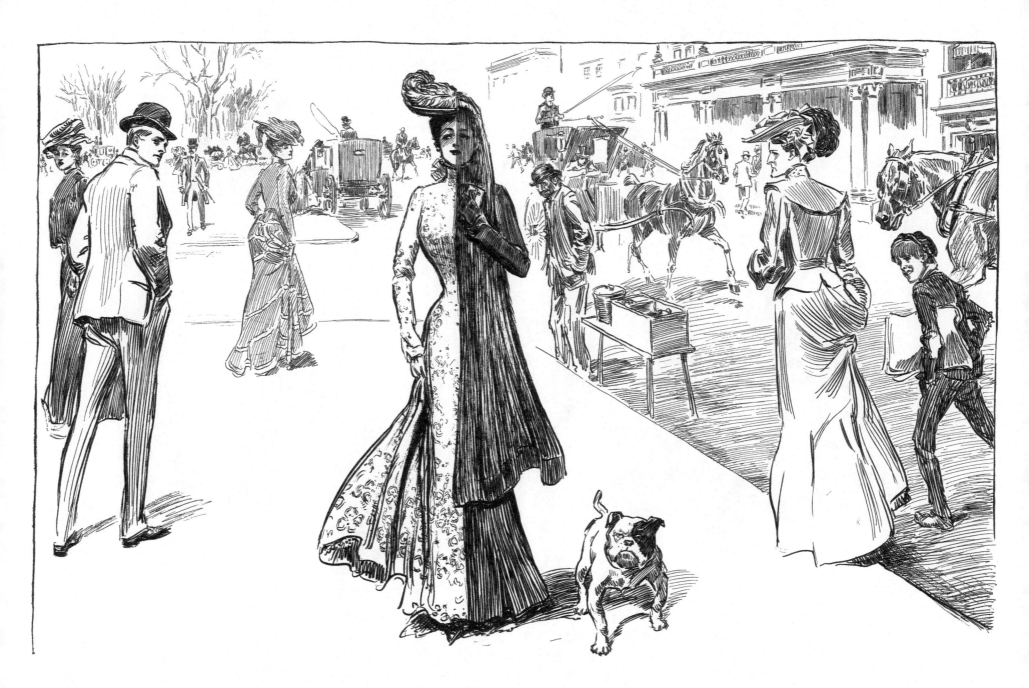

"Half Mourning."

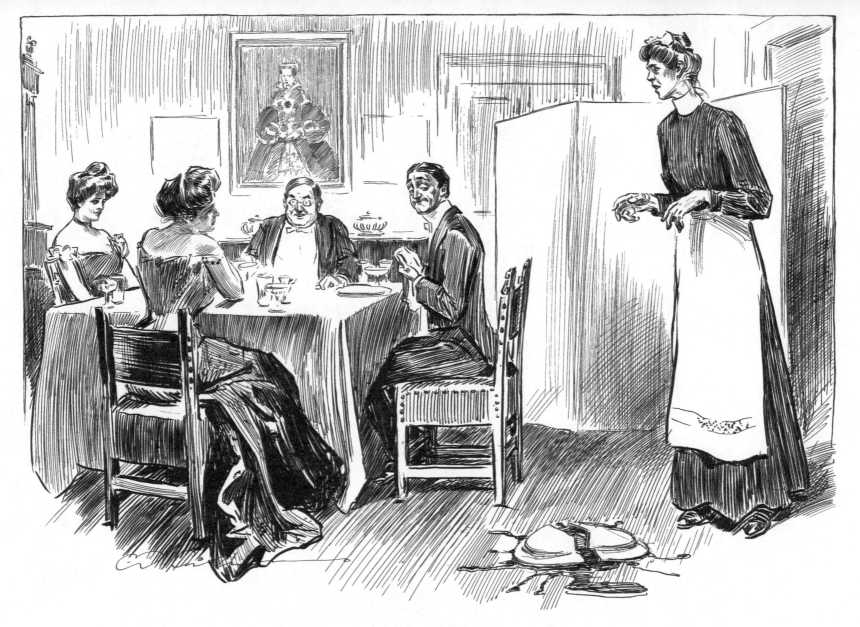

Ferguson (the politest man in New York): "When you go back, Nora, please ask the cook if there is any cold meat in the house." *(Exit Nora.)*

To the company: "I beg you to excuse our maid. These accidents happen to her somewhat overfrequently. She was bred, I believe, a dairymaid, but had to leave that employment because of her inability to handle the cows without breaking off their horns."

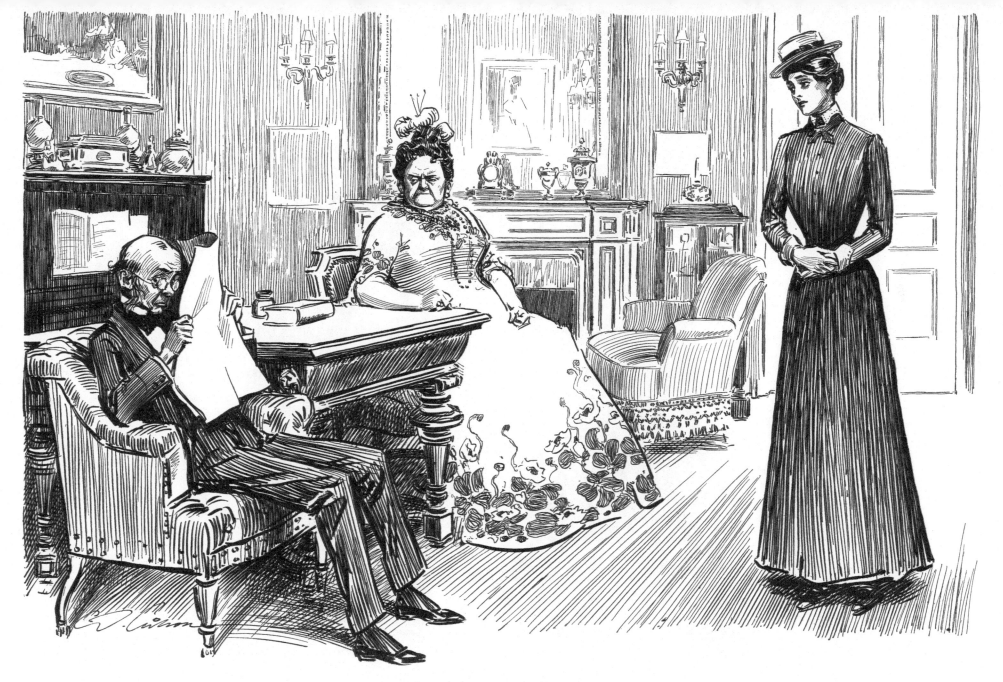

WHY SHE DIDN'T GET THE PLACE.

The man behind the paper ventured the opinion that she might do.

A Happy Faculty.

Young Tutter (to Hostess): "I have had a very pleasant evening. But then I always manage to enjoy myself, no matter where I am."

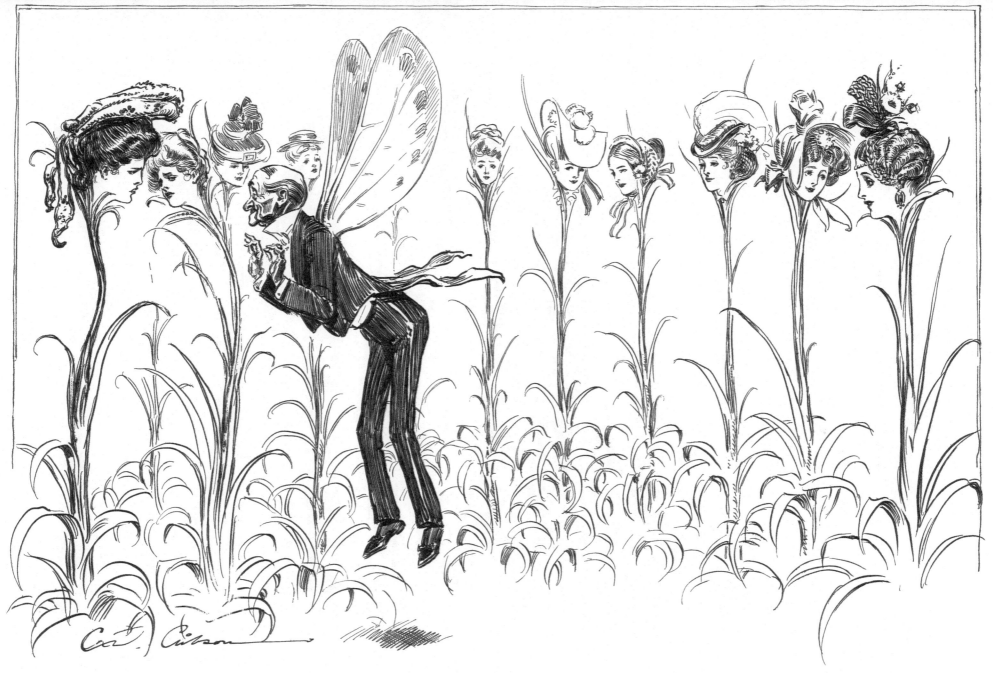

BYGONE SUMMERS.

A frieze for an old gentleman's room.

A Discreet Approach.

"Advise me, Uncle Jack."
"Of course; what is it?"
"Shall I ask you for twenty-five dollars, or for fifty?"

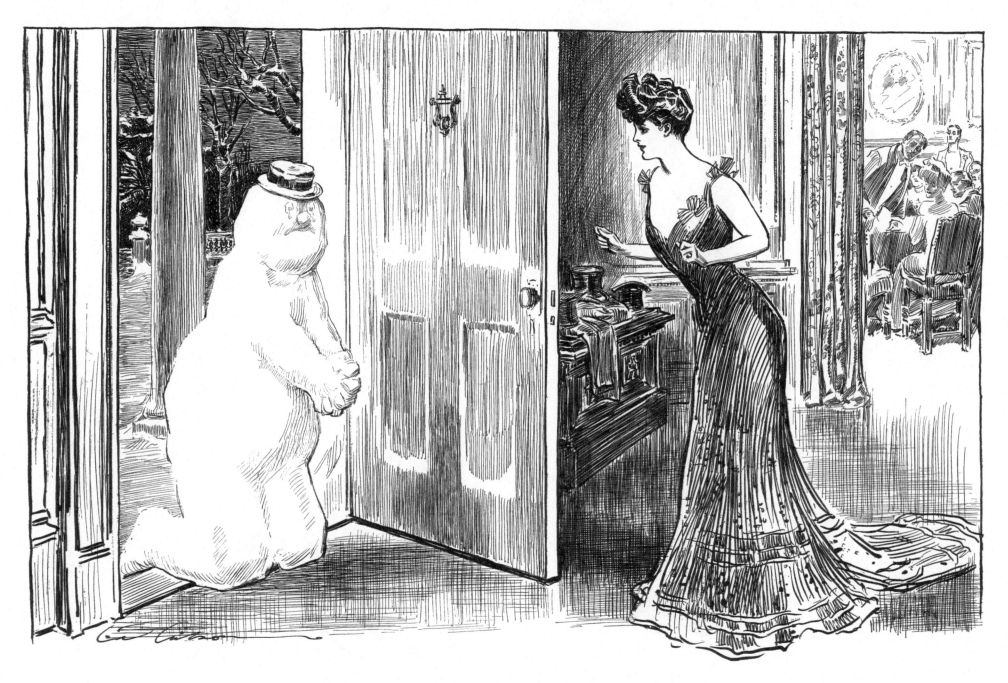

THIS IS THE SEASON WHEN EVEN THE SNOWMAN HAS A HEART.

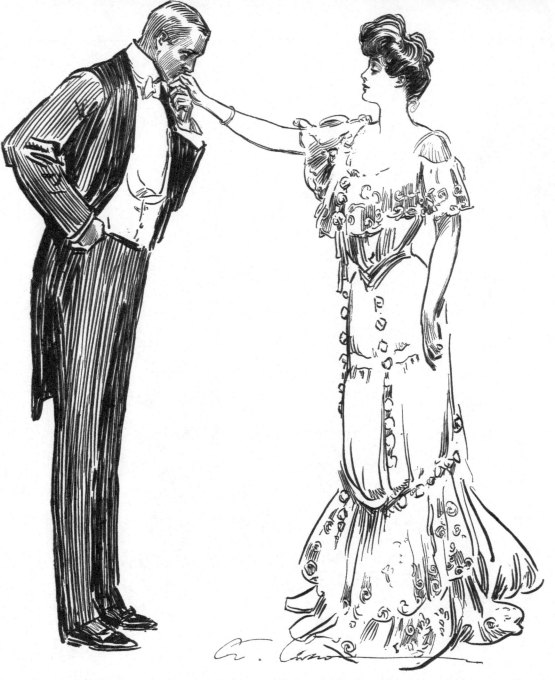

She: "I know that you must have made love before to some other girl."
"But I had you in mind all the time."

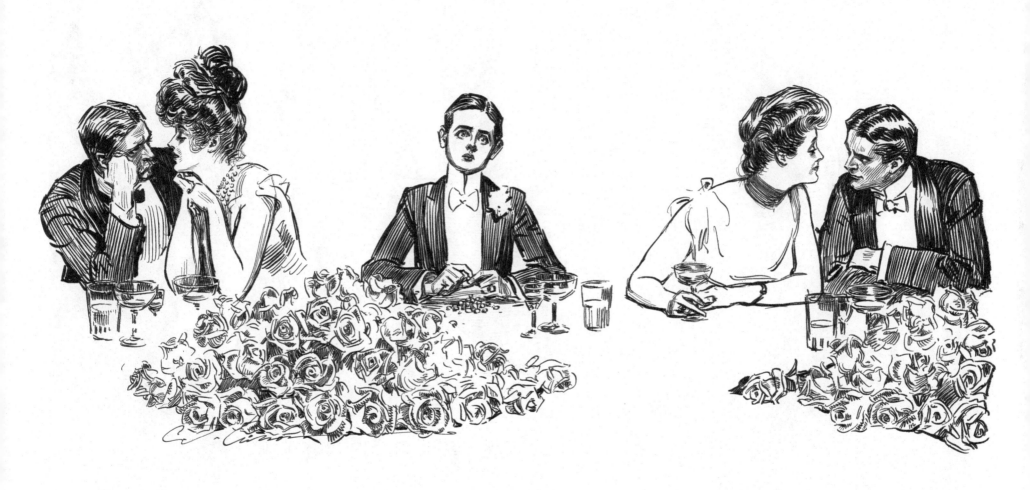

Making Bread Pills.

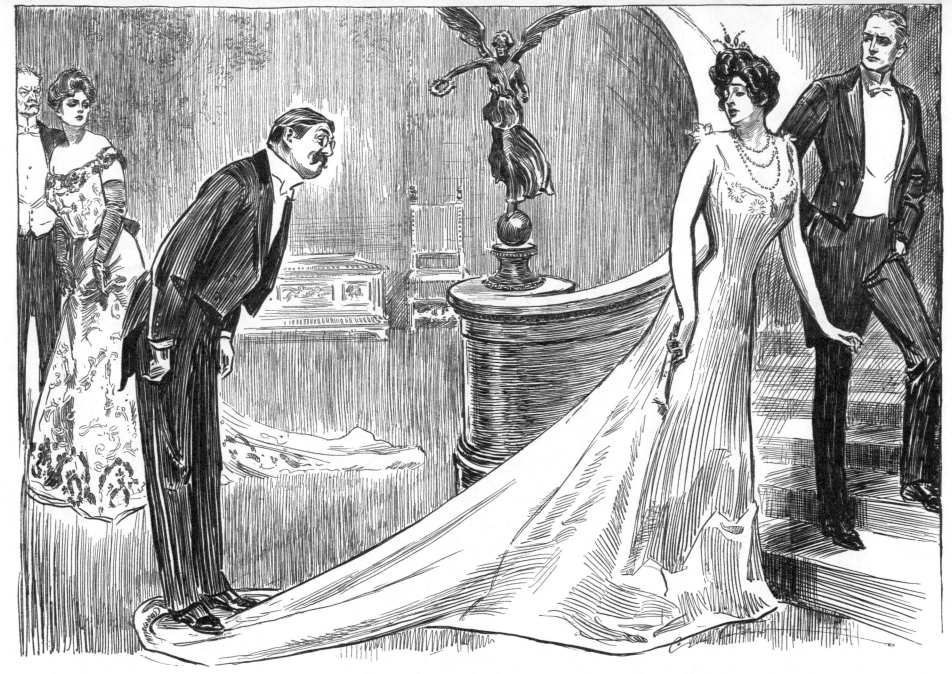

ADVICE TO BORES.

If you cannot make your presence felt by your brains, do it with your feet.

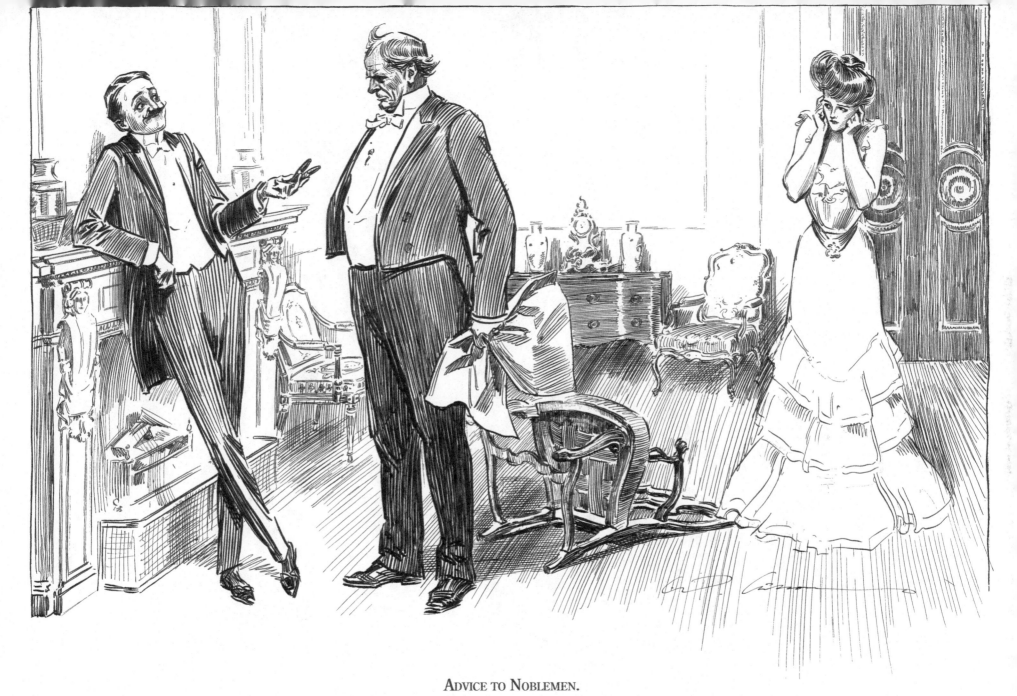

ADVICE TO NOBLEMEN.

When speaking to your fiancé's father assume an easy posture and adopt a friendly manner.

Miss Boston: "Ah, yes; your verses are charming. And have you never written a novel?"
Miss New York: "No; for if I did my mother would never let me read it."

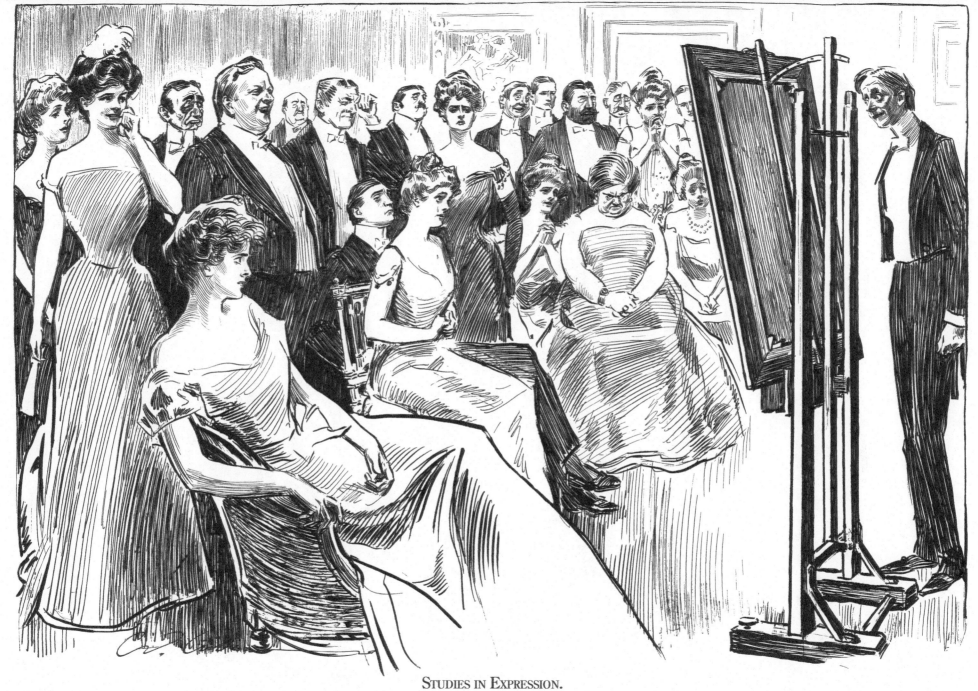

STUDIES IN EXPRESSION.

Daubson shows his latest work.

Actress: "I want you to mention the fact of my diamonds being stolen."
"When did it happen?"
"Next week."

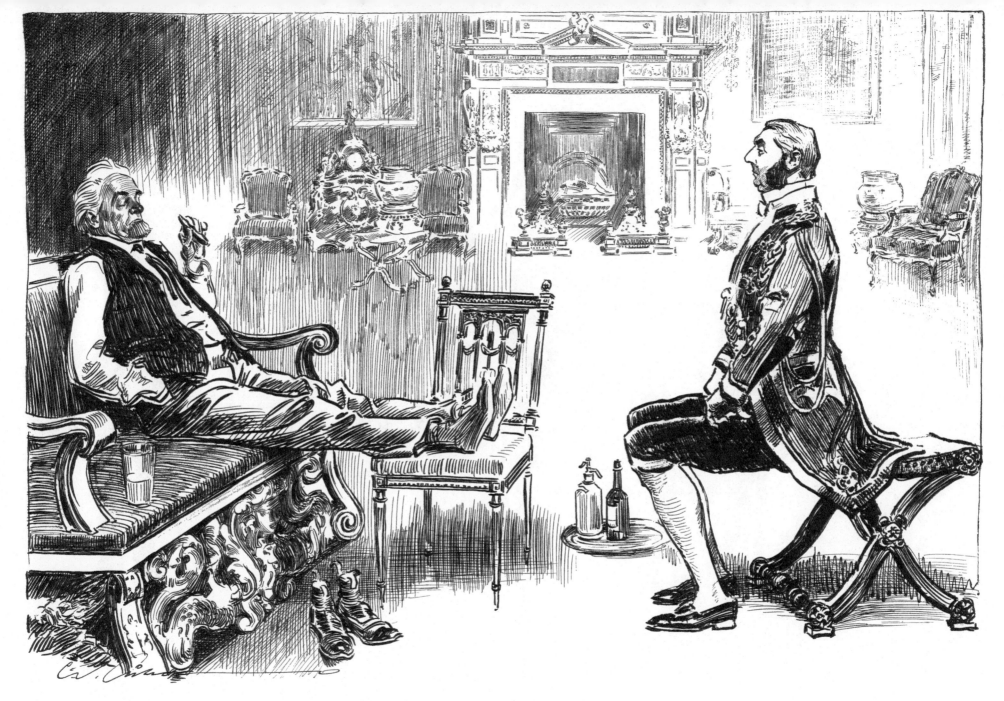

THE RETIRED WALKING DELEGATE OF THE FUTURE.

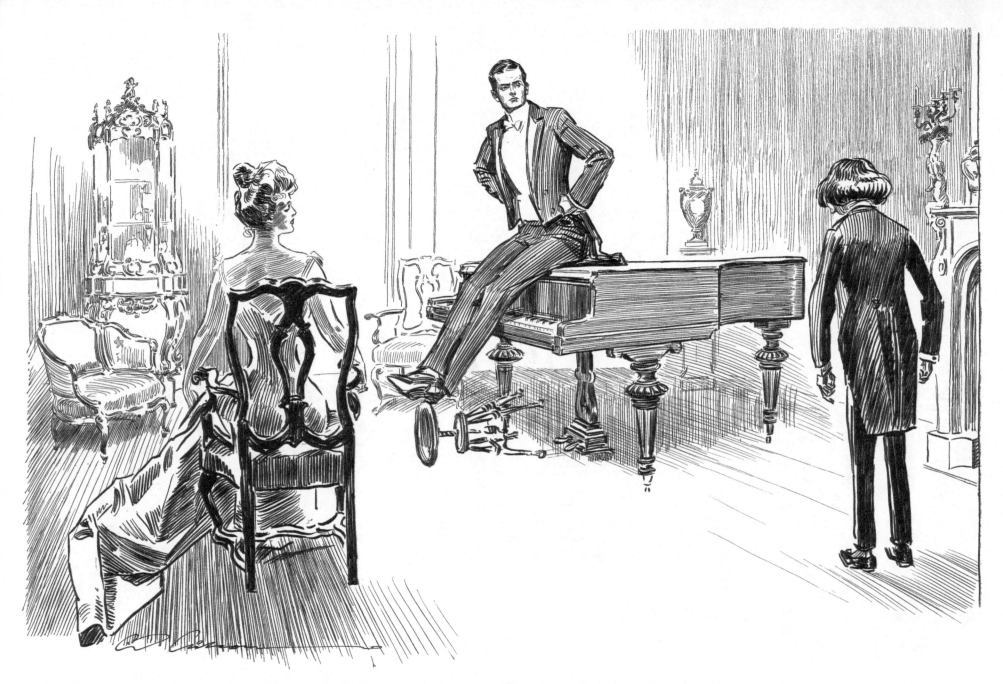

DESPERATE COURSE OF A LOVER WHOSE FIANCÉ IS A CONFIRMED LION-HUNTER.

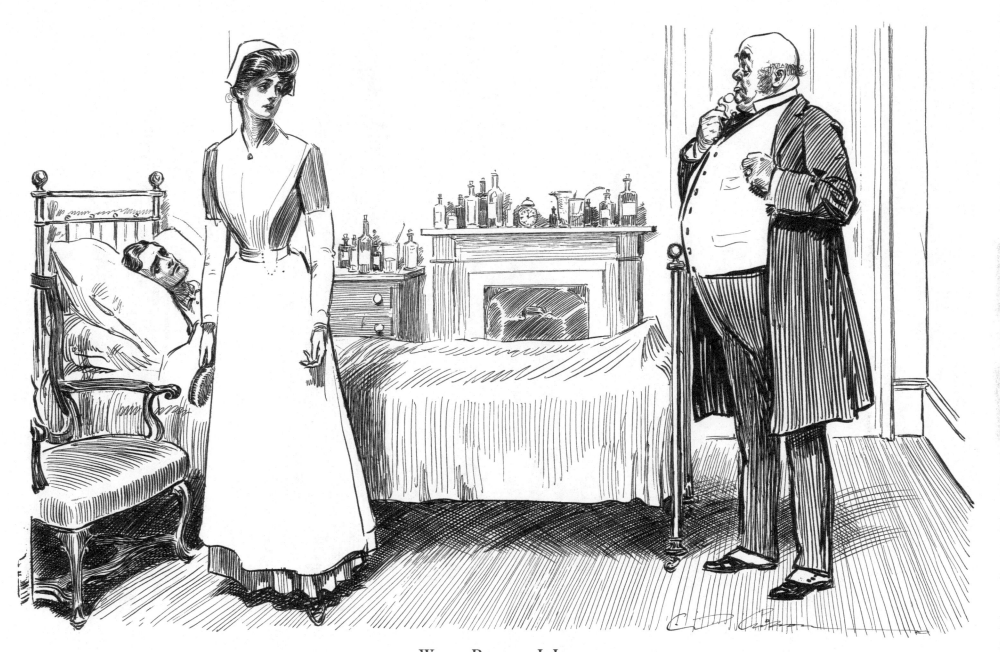

WHEN A BACHELOR IS ILL.

Complications often arise that no amount of medicine will cure.

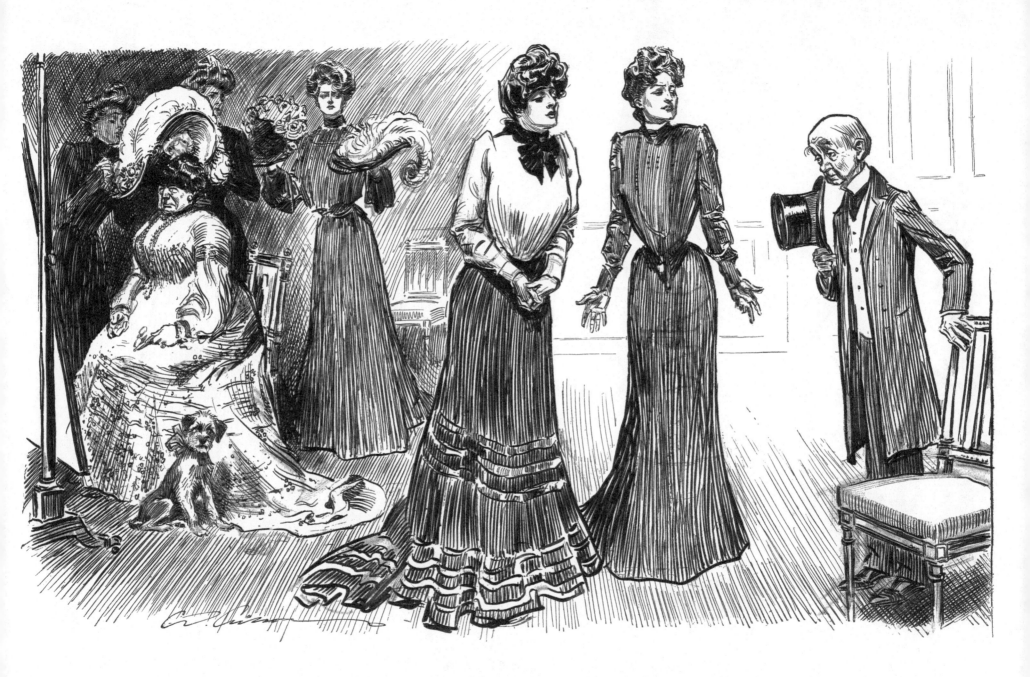

THE BRUTE VENTURES TO SUGGEST THAT A BONNET MIGHT POSSIBLY BE MORE SUITABLE.

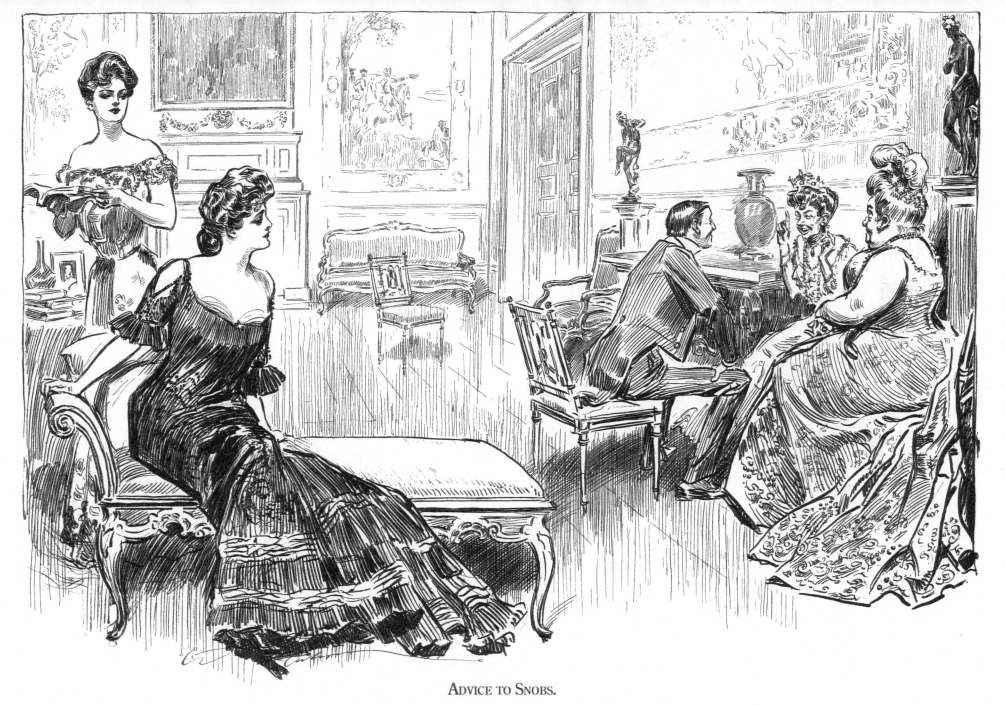

ADVICE TO SNOBS.

If you wish to get on, devote yourself to those who entertain.

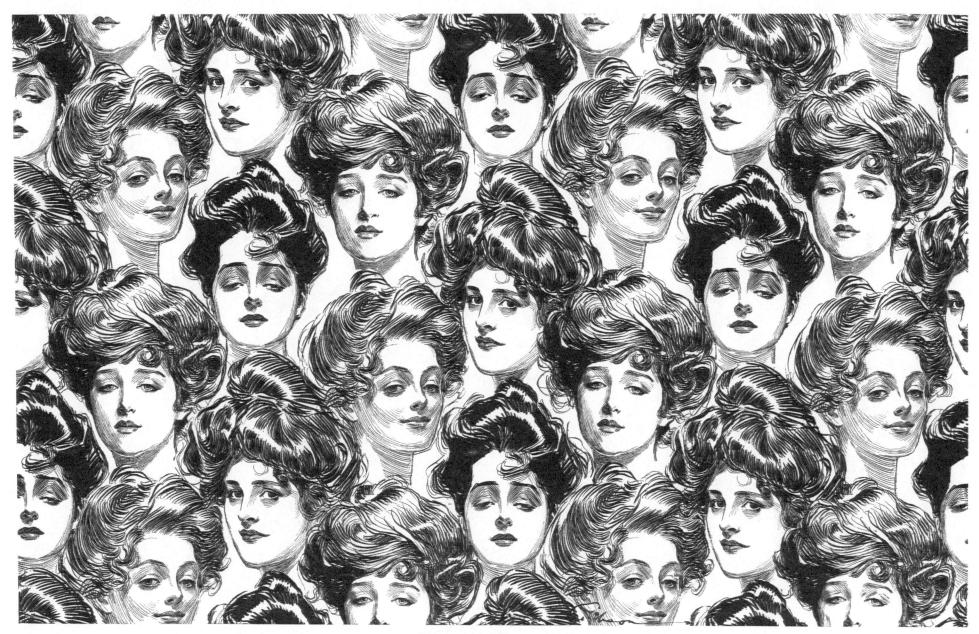

DESIGN FOR WALLPAPER.

Suitable for a bachelor apartment.

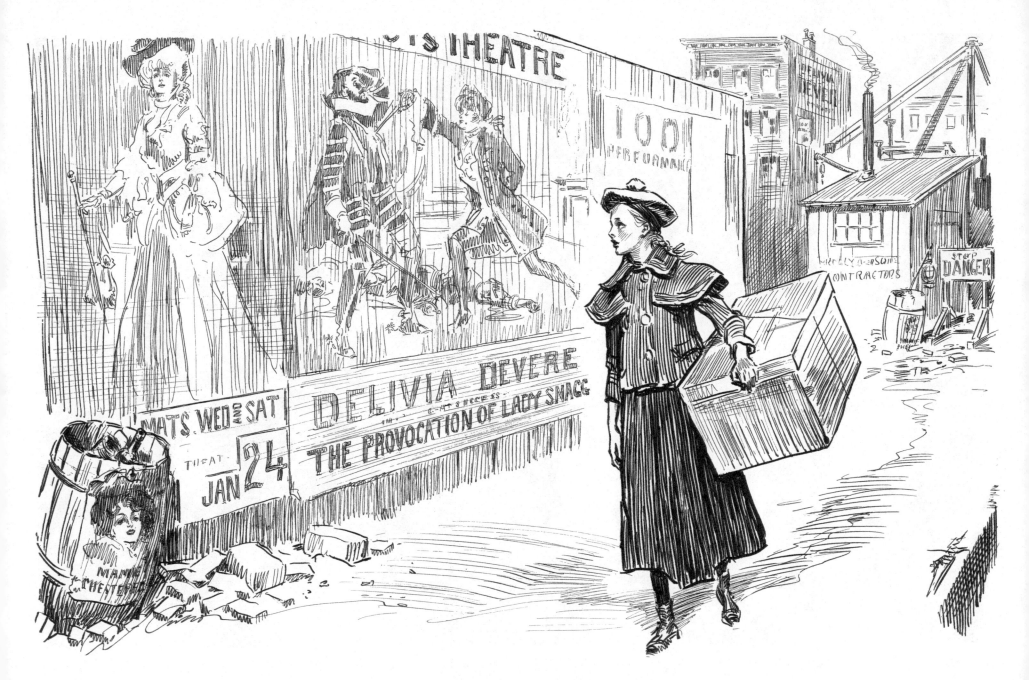

THE SEED OF AMBITION.

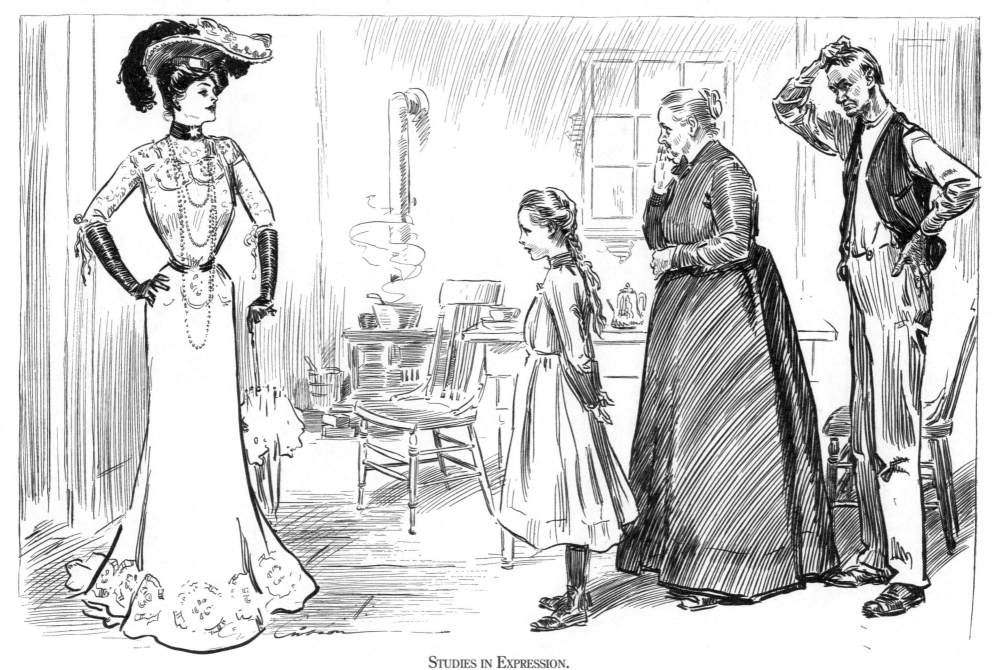

STUDIES IN EXPRESSION.

The "Chorus Girl's" visit home.

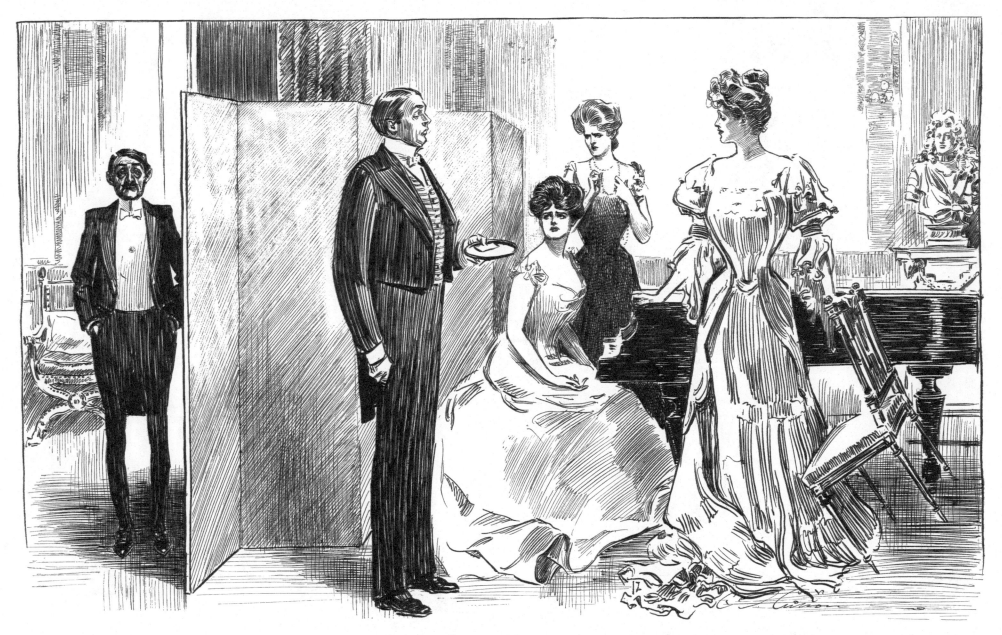

ADVICE TO BORES.

Follow your card upstairs and find out what they really think of you.

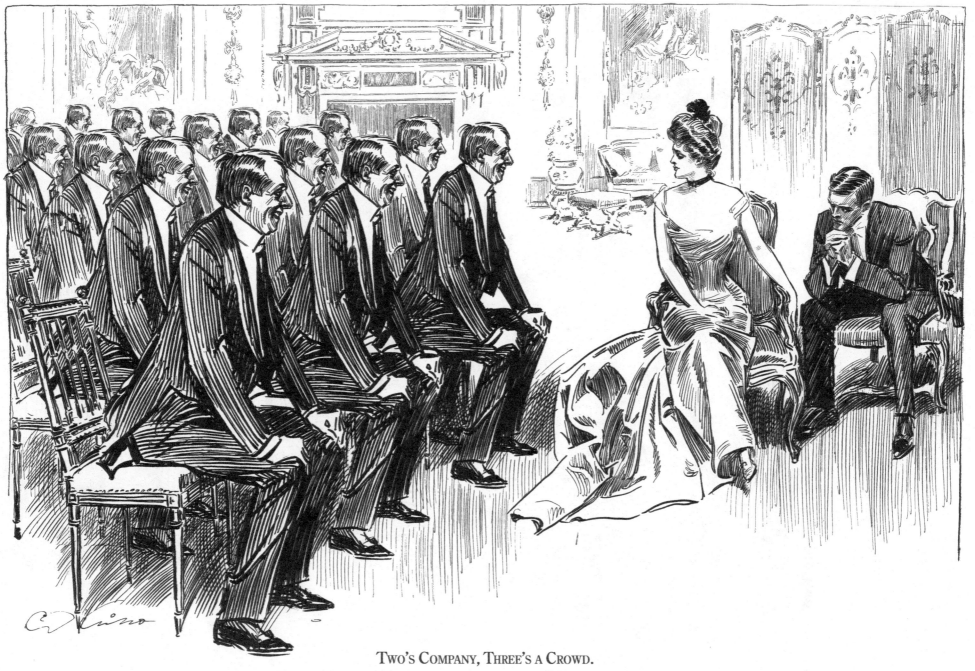

TWO'S COMPANY, THREE'S A CROWD.

The other man should remember that he is a crowd.

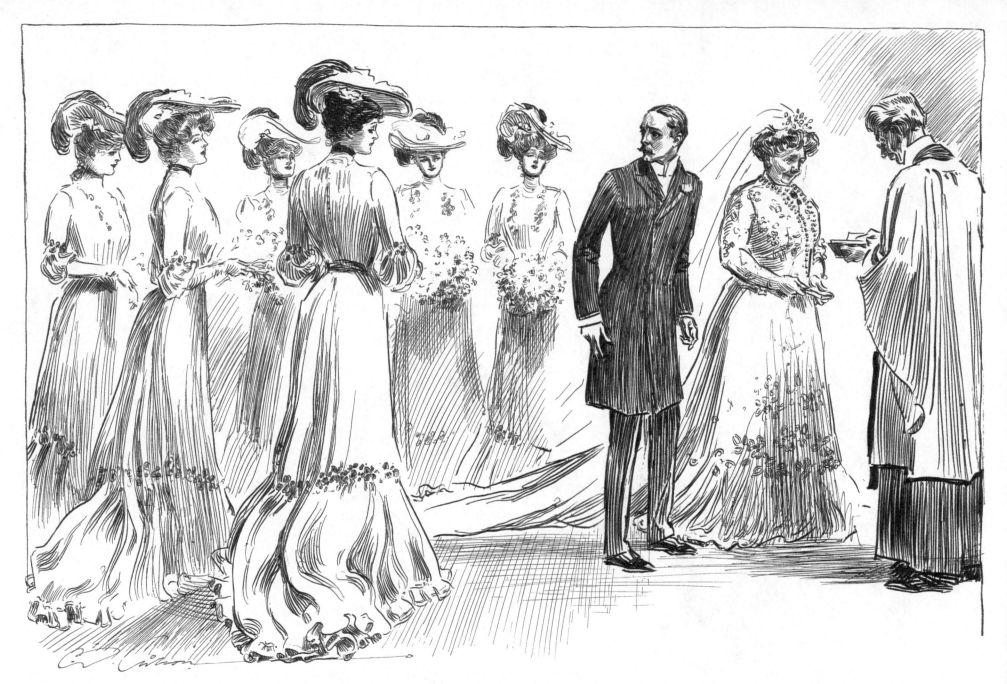

Her Face and—*Her* Fortune.

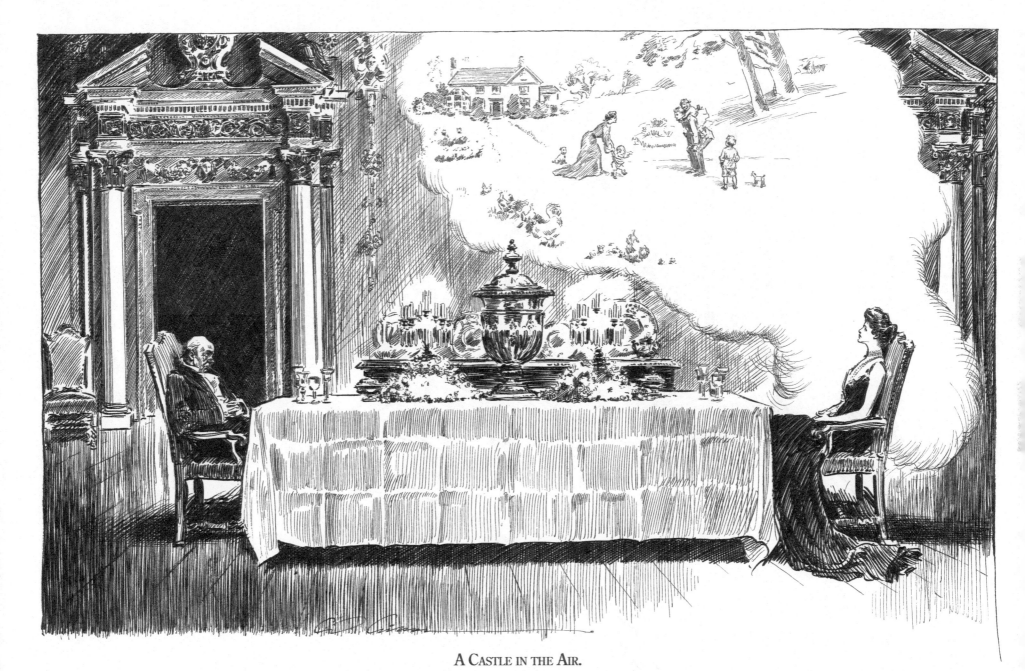

A Castle in the Air.

These young girls who marry old millionaires should stop dreaming.

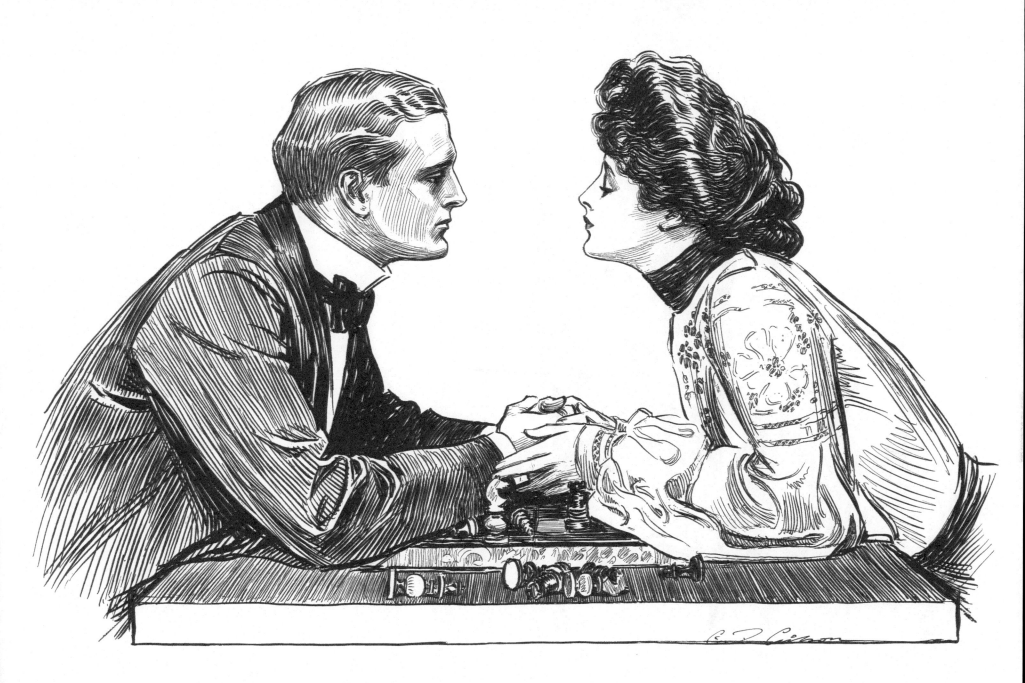

THE GREATEST GAME IN THE WORLD—*HIS* MOVE.